IMAGES
of America

ARLINGTON
TWENTIETH-CENTURY
REFLECTIONS

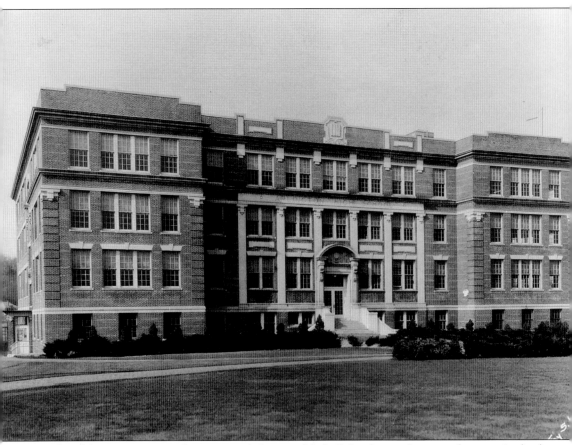

The oldest structure in the current Arlington High School complex was the town's third public high school building. Designed by Arlington architect Howard B.S. Prescott, it opened its doors in 1915 to 600 students in grades 10 to 12. It replaced the 1894 high school on Academy and Maple Streets. Relentless population growth in Arlington had already strained the capacity of the old high school after only ten years; however, there was no adjacent land in the center of town for expansion. About a mile to the west, the new high school could enjoy a true campus setting; the disused millponds to the rear became available to be filled in for athletic playing fields.

Although most classes were coeducational, boys and girls were required to use separate side entrances on the ground level, in keeping with social attitudes of the day. This notion was expanded in the 1930s, when overcrowding led to discussion of a second building. One campus configuration called for the establishment of separate girls' and boys' high schools. Debate on this option did not go far, as it was found to be inconsistent with emerging national standards for modern secondary education.

IMAGES
of America

ARLINGTON
TWENTIETH-CENTURY
REFLECTIONS

Richard A. Duffy

ARCADIA
PUBLISHING

Published by Arcadia Publishing
Charleston, South Carolina

Printed in the United States of America

Library of Congress Catalog Card Number: 99069232

For all general information contact Arcadia Publishing at:
Telephone 843-853-2070
Fax 843-853-0044
E-mail sales@arcadiapublishing.com
For customer service and orders:
Toll-Free 1-888-313-2665

Visit us on the Internet at www.arcadiapublishing.com

For Cup²

Contents

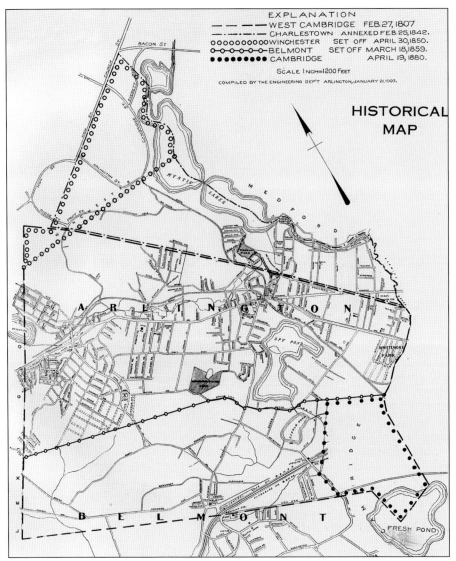

EXPLANATION
— — — — WEST CAMBRIDGE FEB.27,1807
—·—··—·— CHARLESTOWN ANNEXED FEB.25,1842.
ooooooooooWINCHESTER SET OFF APRIL 30,1850.
o-o-o-o-o-o-BELMONT SET OFF MARCH 18,1859.
●●●●●●●●● CAMBRIDGE APRIL 19,1880.

SCALE 1 INCH=1200 FEET
COMPILED BY THE ENGINEERING DEP'T ARLINGTON, JANUARY 21,1907.

HISTORICAL
MAP

This historical map was published in 1907, the centennial year of Arlington's establishment as an independent town. (Arlington was known as West Cambridge until 1867.) The map displays all of the territorial gains and losses of the 19th century that produced the town boundaries that have existed ever since.

As a visual tool to understand the history of the 20th century, it is interesting to see the large sections of white space on this map. Almost all of these lands were under active cultivation as market gardens and supplied Greater Boston with fresh vegetables that were grown in its fields and greenhouses. There were very few acres of woodlands, only two of which (Menotomy Rocks and Meadowbrook) were protected as parks at the beginning of the century. As a result, streets and houses now cover most of the open tracts shown here. In fact, the golf course of the private Winchester Country Club, established in 1902, is one of Arlington's largest open spaces.

The millponds, running west to east through the center of Arlington, were filled by mid-century to create the town's playing fields. It is interesting to realize that many of the recreational facilities of the 20th century are the legacy of what were once the principal industrial features of Arlington's landscape.

Introduction

Arlington's *Annual Report* features a rather convenient section that includes, among other information, Arlington's geographical situation as "six miles northwest of Boston, in latitude 42 degrees 25 minutes north; longitude 71 degrees 09 minutes west." It is probably safe to say that these data form the only aspect of "Arlington by the numbers" that stayed the same from one end of the 20th century to the other. Other numerical categories show movements over the last 100 years that are tremendously revealing. In 1900, Arlington's population stood at 8,600. It had gained another 10,000 residents by 1920, and these 18,000-plus souls doubled to over 36,000 in a single decade. In 1945, the population had reached approximately 44,000 and steadily grew to its peak of more than 52,000 by the mid-1960s. Population registered a declining trend in the late 1970s that seemed to have leveled off to approximately 44,000 in 1999.

In 1900, Arlington operated five public schools. This increased to a total of 16 schools (including the Industrial Arts School, a predecessor of Minuteman Tech) that were operating simultaneously in the 1960s. Systemwide consolidation that began in 1979 has left the town with its present total of nine schools.

Looking at school operations and population together, it is interesting to observe that in 1950, Arlington had more or less the same total population it had in 1999, but it operated 33% more schools, with many more students per classroom in each. We can accurately infer that Arlington continued to grow in terms of housing units, but that it now has a much different family profile than had been the case for most of the 20th century.

This small sampling of dates, facts, and figures does a pretty good job of summarizing Arlington's transformations in the 20th century; however, interesting data frequently make for lifeless history. So, this book has been created to showcase the variety and vibrancy that characterized Arlington's growth in the last 100 years. The 20th century was that in which Arlington achieved its ultimate destiny as a residential suburb. This passing of the old to make way for the new truly must be seen to be appreciated.

This book takes a dual approach to presenting the 20th-century history of Arlington in images: chronological and by topic. Chronologically, four of the six chapters cover one-quarter century each, transporting readers along a sort of visual timeline. This method was selected simply because it seemed as good a means as any to ensure that the book would nicely balance photographs throughout the entire 100 years. But as the final layout took shape, it was striking to see that a very clear symbol of transition from one historical era into another had emerged.

The printed divisions of the material had turned out to be much more than convenient stopping and starting points.

Two smaller single-subject chapters have been placed together at the mid-century point of the chronological sections of this book. Each topic was chosen to stand on its own for its unique ability to exemplify transformation and continuity from the early years of the 20th century to current times and beyond. The special stories conveyed by these images would have become diluted if left to crop up throughout the book as individual photographs in different time periods.

The first of the topic-chapters, "The Order of Saint Anne and Its Legacy," beautifully captures the evolution of social and educational services for children in this century. For almost two decades, this order of Episcopal nuns operated an orphanage that favored a homelike approach to caring for children in a group setting—a concept that was ahead of its time in an era where the institutional orphanage model prevailed. The subsequent 50 years were devoted to running St. Anne's boarding school for girls. Again, the home-away-from-home for the students remained a compelling mission and was no mere marketing slogan. For the last 20 years, Germaine Lawrence, Inc. has operated on the site of St. Anne's as a program that operates independently of the religious order, but which embodies so many of its original values. It continues to grow as a successful model of progressive care and residential treatment for girls who have emotional challenges and opportunities that were utterly unforeseen when the 20th century began.

The second topic-chapter, "Greetings from Arlington," presents postcards through the decades. These images are particularly compelling for their very reason for being. The important features of Arlington were mass-produced as views that were ultimately destined for an audience of ordinary people located far away. As such, postcards might be described as the town "getting dressed up to go visiting." It was therefore vital for postcard manufacturers to capture the kind of images that Arlingtonians would be pleased to purchase and send.

Whether posed or candid, monumental or mundane, somber or celebratory, each of the images in this book, by definition, serves as an important historical reflection of Arlington in the 20th century. That fact that "the camera doesn't lie" lets us approach the photographs in their simple integrity. The words that accompany each image serve to enhance an already satisfying viewing experience by drawing attention to details and providing the context that makes for a more complete historical account of the town.

With both a new century and the symbolism of the third millennium soon upon us, this opportunity to visually follow the course of events of the last 100 years will surely influence our dreams and expectations for the kind of place Arlington will be in the decades to come.

One

1900–1924:
Agriculture Yields to
Suburban Destiny

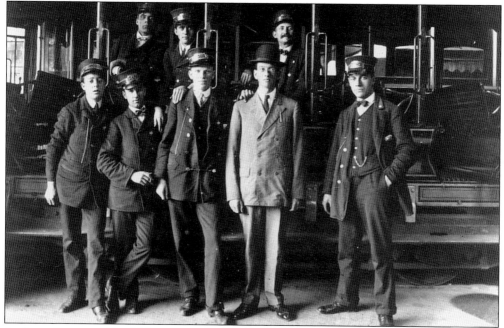

In the early years of the 20th century, Herbert C. Hurd, far right, posed with some of his fellow workers of the Boston Elevated Railway Company (a predecessor of today's MBTA) at the Arlington Heights terminus. Hurd, of 20 Sutherland Road, was a streetcar conductor for many years. Notice the open-sided car, used in the warmer months of the year until 1917.

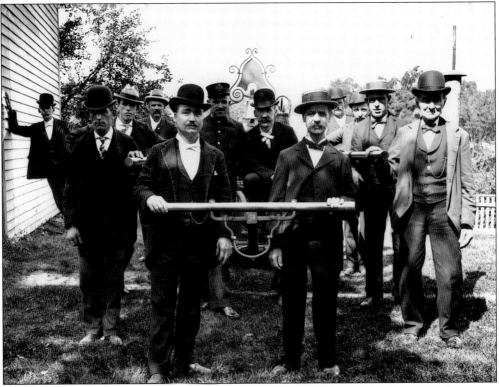

Leading the past head-on into the future are members of the Arlington Veteran Firemen's Association. They are preparing to accompany the town's original hand-pumped fire engine, the "Eureka," as it travels the route of the 1900 Patriot's Day parade.

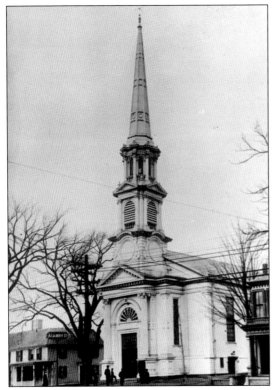

This *c.* 1906 photograph of the Universalist church is perhaps the best existing view of the structure and its magnificent steeple, which was taken down after the 1938 hurricane. At the beginning of the century, there were four such tall spires; none exists today. In 1964, the Universalists formed a new denomination with the Unitarians, and their church was sold to the Greek Orthodox congregation.

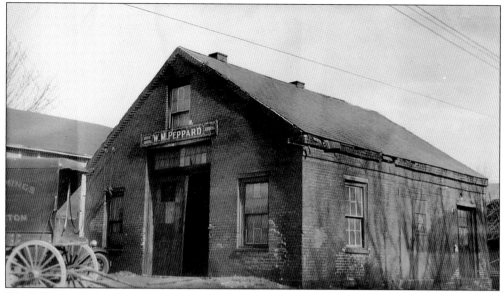

W.M. Peppard's blacksmith shop stood at the corner of Massachusetts Avenue and Grove Street; it continued to provide horseshoeing and jobbing well into the 20th century. The milk wagon of Arlington's Cummings Dairy can be seen at left.

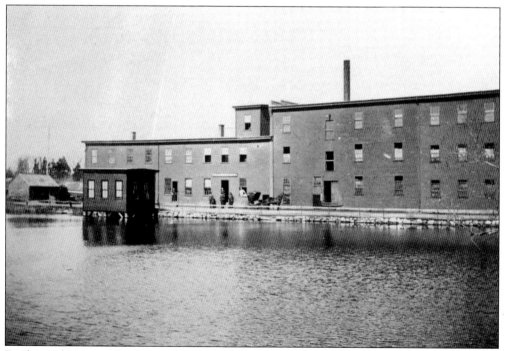

Fowle's Arlington Mills, famous for its Arlington brand wheat meal, operated at the site of the town's very first mill from 1863 until going bankrupt in 1911. Filling the millpond after 1940 created the present-day Buzzell Field. The Cusack Apartments for the Elderly and the 1983 Community Safety Building stand on the site of the former mill-building complex.

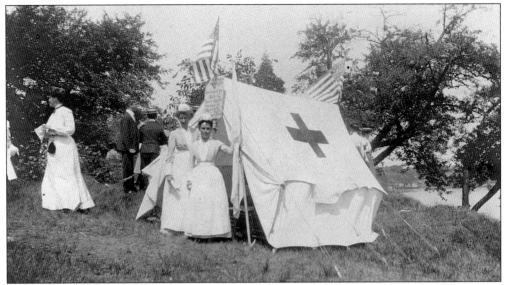

The newly created District Nursing Association (a predecessor of today's Visiting Nurses) was established in 1904. In that same year, the association participated in a Country Circus on the shores of Spy Pond to raise money for their privately sponsored work.

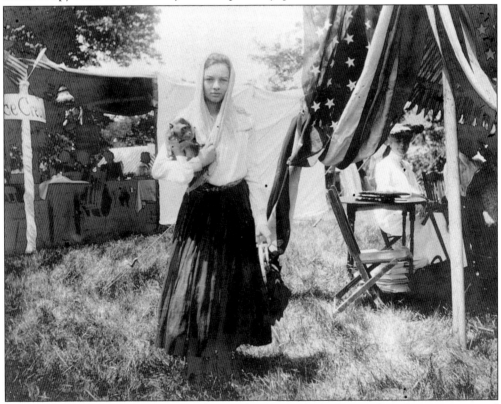

A local girl in "Gipsy" attire—complete with costumed monkey and tambourine—amused circus-goers with her fortune-telling act. Homemade ice cream was being freshly cranked for eager customers under the adjacent tent.

Since ice cream would be consumed almost as quickly as it was made, the absence of mechanical refrigeration in the early 20th century meant that tiny local dairies were an essential feature to serve the milk-and-butter needs of suburban neighborhoods. John Pichette ran a dairy at the corner of 48 Broadway and Marathon Street, which he later converted into one of Arlington's first gas stations. This cardboard disk was used to hold the milk bottle cap in place.

JOHN L. PICHETTE

PERFECTLY PASTEURIZED

48 BROADWAY, ARLINGTON

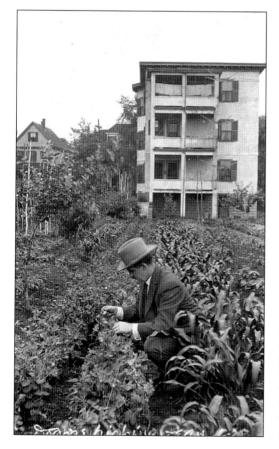

William Doane, a photographer who captured many scenes of Arlington's development in the early 1900s, is shown picking peas in his Arlington Heights backyard. Although that section of town had already grown in density, large vegetable plots and a chicken or two were still quite common to see. This photograph may be a self-portrait.

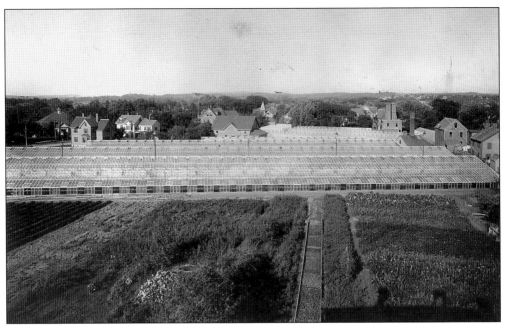

The home and the enormous greenhouses of Warren W. Rawson were located near the intersection of Medford and Warren Streets. Here, Rawson developed popular varieties of "early" vegetables (several bearing the Arlington name) which led to a successful seeds business at Faneuil Hall. Despite this fame, development pressures so near the center of Arlington meant that Rawson's hothouses were among the first to vanish in this century.

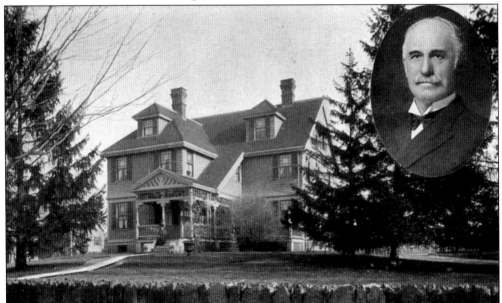

As the author of the popular handbook *Success in Market Gardening*, Warren W. Rawson was a celebrity in a town that already enjoyed widespread fame as an agricultural community. This photograph of Rawson's homestead, with Rawson's portrait in vignette, was taken while he served as a governor's councilor. The image was included as one of the the top-eight Arlington attractions in a souvenir postal letter of the early 1900s.

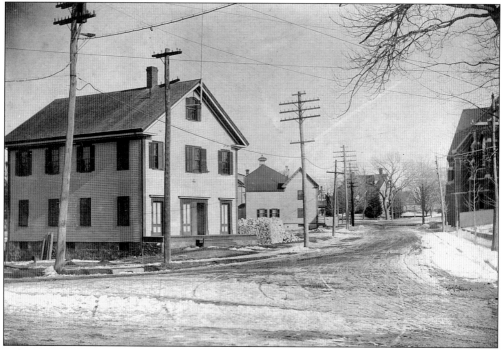

"Chestnut Hall" (later home to the Hibernians) occupies the northeast corner of Chestnut and Mystic Streets. Looking straight up Chestnut Street, we see W.W. Rawson's homestead (today the site of the St. Agnes Convent) and a glimpse of the greenhouses where today's St. Agnes Grammar School stands. A section of St. Agnes Church is easily recognized to the right.

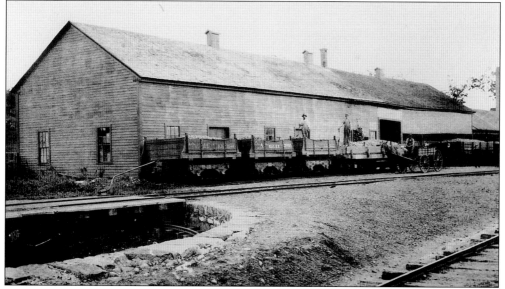

Peirce and Winn's coal yards occupied a large tract in the town center until oil and natural gas predominated as home-heating fuels by the mid-century. Sidetracks adjacent to the Bedford branch line of the Boston and Maine Railroad were critical to the efficient movement of the thousands of tons of coal delivered here. Other major coal depots included Kelly's (near Brattle Station) and Arlington Coal and Lumber (in the Heights).

"The Hollows" was a magnificent Queen Anne-style home on the shore of the Upper Mystic Lake. Sometime after 1905, Jack Cronin purchased this house and transformed it into an "antebellum" mansion of sorts, adding a two-story porch supported by massive Ionic columns he had salvaged from a church in Newton. A present-day view of Cronin's Southern-gentleman fantasy can be found on page 124.

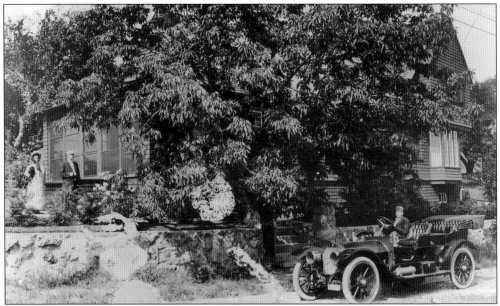

Just up the street from "The Hollows" was "YousaY," the home of Moxie soft drink executive Freeman Young and his wife, Emma. In this section of a panoramic photograph, the Youngs are shown in their garden at the southern junction of Old Mystic and Mystic Streets, while their chauffeur awaits them in the automobile below.

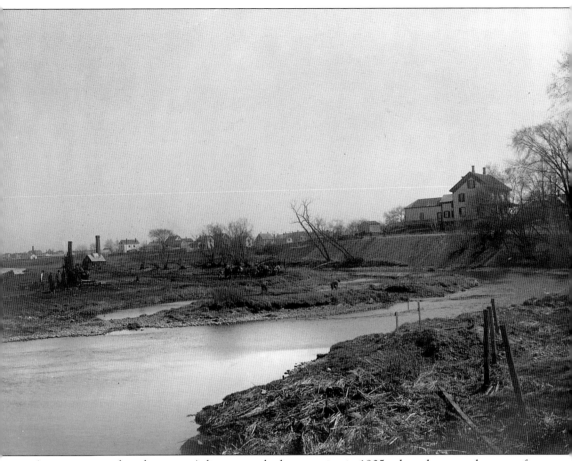

A major geographic change in Arlington took place starting in 1905, when the natural course of the Mystic River was moved into a man-made channel to permit the construction of the Mystic Valley Parkway. Note the steam-powered excavation equipment in the left foreground. This renovation was part of a large public works project to control flooding and to create parklands and scenic boulevards along suburban waterways in Greater Boston. It was considered complete once the Cradock Dam at Medford Square became fully operational in 1910. After that time, the tidewaters of the Atlantic no longer made their way into Arlington, and the upper section of the Mystic River became exclusively a freshwater stream.

The house on the bluff overlooking the Mystic River is still standing at 181 Franklin Street. Benjamin F. Woods built it, c. 1852, at the same time he established a woodworking tide mill on the Mystic River. His was only the second tide mill in Arlington history, its predecessor having been the 17th-century grist- and fulling mills located on the Mystic near the Alewife Brook. Woods's mill harnessed the barely 3-foot tidal range for waterpower to assist in the manufacture of parlor brackets and baby carriages. After years of battles with pleasure boaters from Medford, the milldam was removed in 1872, having been declared an obstacle to navigation by the Massachusetts State Supreme Court.

Prominent Arlington author J.T. Trowbridge fictionalized the colorful real-life struggles of Benjamin Woods as *The Tinkham Brothers' Tide-Mill*. This 1882 novel, republished in a special expanded edition in 1999 by the Arlington Historical Society, has reawakened awareness of Arlington's fascinating past as a tidewater community. (Medford Historical Society.)

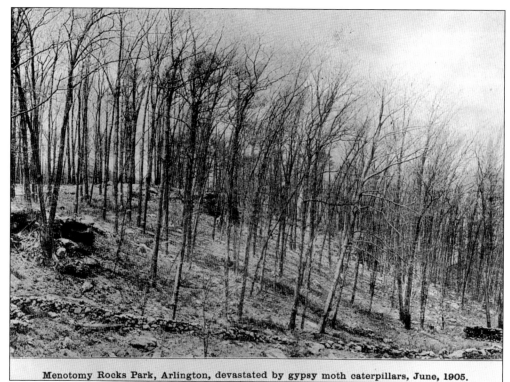

Menotomy Rocks Park, Arlington, devastated by gypsy moth caterpillars, June, 1905.

Another important change in the Arlington landscape in 1905 was the devastation caused by the gypsy moth, which denuded the trees throughout Menotomy Rocks Park and the surrounding areas. Replacement trees were of varieties selected to resist major attacks of the pest, the most recent of which occurred in 1981.

The house at 40 Irving Street was photographed in 1902. Always exceptionally picturesque, it gained both friends and foes in 1996 when it was cloaked in a fanciful paint scheme of lavender with seven different accent colors. Built in 1867, its original "side-hill cottage" design located the kitchen and servants' quarters on the basement level. Sited on the edge of the former George H. Gray estate, this is one of the anchor properties in the newly created Jason-Gray historic district.

At the corner of Pleasant and Irving Streets, a cow grazes in the lot next to the 1907 "Irvington" apartment building, which was the very first such block in Arlington. Although a radical architectural departure from the mansion-houses that had characterized Pleasant Street, the Irvington was very much intended to attract tenants wealthy enough to have live-in help to occupy the maids' suites behind the kitchens. The sign attached to the tree in front of the Irvington warns a particular kind of driver: "Automobiles Go Slowly. Dangerous Turn." Pleasant Street was widened and straightened in 1959, during which it lost its extraordinary canopy of ancient shade trees. It has since sprouted many more apartment blocks and serves as one of Arlington's principal arteries to and from Route 2. (Society for the Preservation of New England Antiquities.)

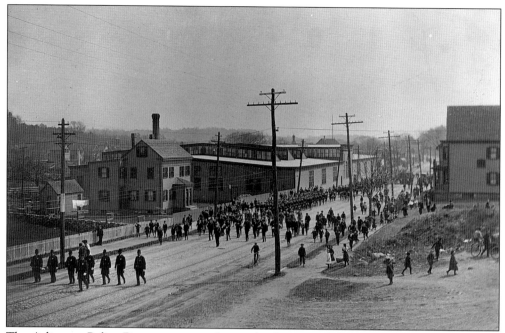

The Arlington Police Department marches in the foreground during the Patriot's Day parade of 1906. Following behind are the youngest veterans of the day—those who had served in the Spanish-American War. In the large building on the right, electric streetcars were sheltered and maintained at the end of the line in Arlington Heights. The structure was referred to in the plural as the "carbarns."

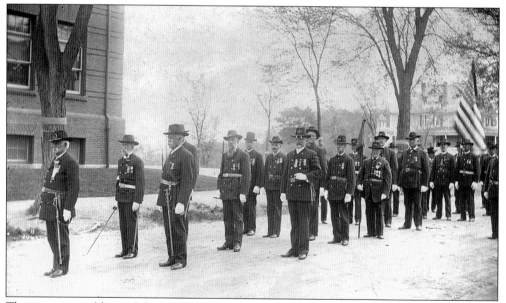

The surviving soldiers of the Civil War were remarkably numerous and greatly venerated in the 1907 celebration of Arlington's centennial as a separate municipality. (As an independent town, Arlington was called West Cambridge from 1807 until its renaming in 1867.) Here, the veterans are shown behind the Locke School, assembling to march as a unit in the town's 100th birthday parade.

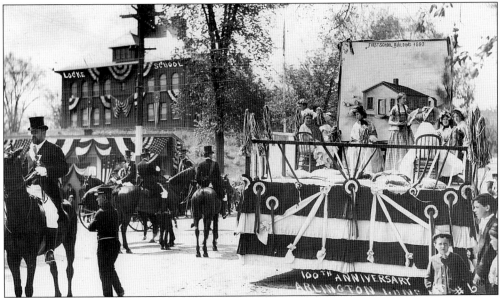

A 1907 float of Arlington's first school building accurately depicts its location among the gravestones of the Old Burying Ground. The 1899 Locke School, at left, was converted into condominium units in the 1980s.

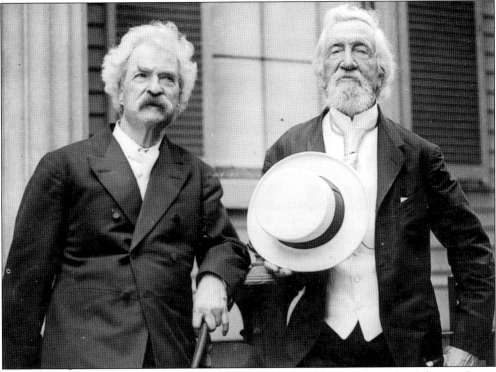

Samuel L. Clemens, left, (better known as Mark Twain) paid this visit to the Arlington home of his friend and literary colleague John Townsend Trowbridge in the early years of the 20th century. Trowbridge, who was among America's most popular and respected authors of juvenile literature, lived at 152 Pleasant Street from 1865 until his death in 1916.

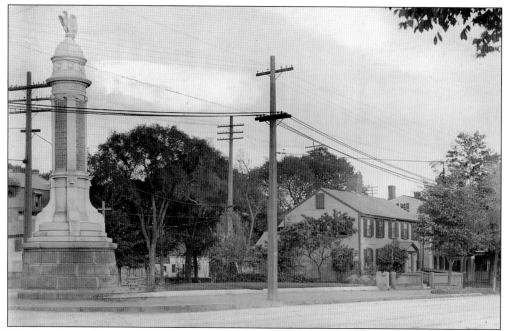

The late Henry Castle of Plainville, Connecticut, visited Arlington, Lexington, and Concord in the early 1900s to photograph "shrines" of the American Revolution. In this extremely rare shot, we see the 1887 Civil War Monument in the left foreground, with the 18th-century Amos Whittemore House on the right. The Central Fire Station occupies the site of the house today.

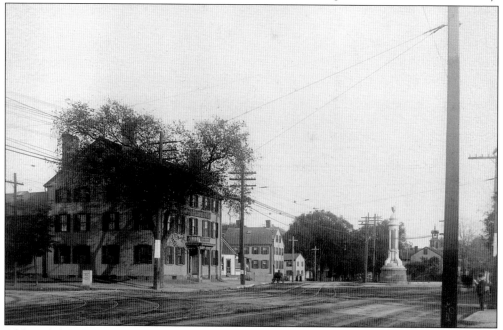

Although labeled "Coopers Tavern 1775," the Arlington House hotel, on the left, was not constructed until 1826. We can date Henry Castle's photograph to 1900 or later, due to the presence of streetcar tracks running down Broadway in the middle of the view. Castle's important series of photographs was donated to the Arlington Historical Society in 1999.

The Jason Russell House was still a private residence when this picture was taken. Its front path was then the only frontage it had on Jason Street. Houses had been built on all sides of the Jason Russell House, covering the historic battlefield. Note the baby cradle in the lower right corner; Henry Castle's photographs are exceptional for their era because they did not try to hide the modern context of the historic sites.

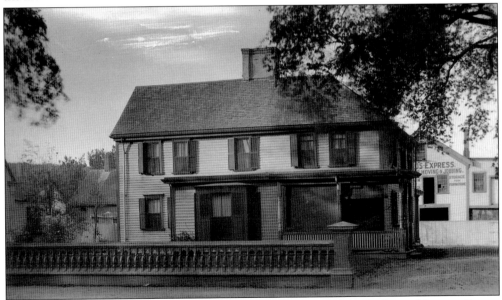

This is perhaps the finest view ever captured of the Stephen and Molly Cutter House, adjacent to the Universalist (Greek Orthodox) church. Remarkably, Henry Castle photographed it with a camera that he made himself. It is especially interesting to see the house with a section of the Woods Express barn to the rear. Other surviving views of the house omitted this background.

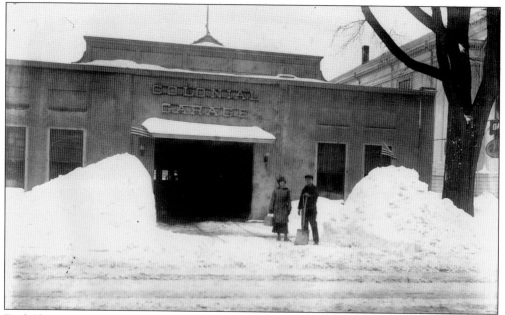

Fred Chase spent his boyhood in the Stephen Cutter House, but its prime location in Arlington Center and Chase's love of the automobile business led him to sacrifice history for progress. He tore down his home to build the Colonial Garage, shown here *c.* 1917. Most recently the former location of Time Oldsmobile, the site came up in an appeal by Osco Drug, which sought and was denied a permit to construct there in 1999.

Note the Colonial Garage's Socony Motor Gasoline pump, topped by an illuminated glass advertising globe. The pump was located directly at curbside, an arrangement that caused traffic congestion once two or more cars lined up in the street. Even greater was the hazard of vehicles swerving into pumps, which banished curbside filling stations by the 1930s.

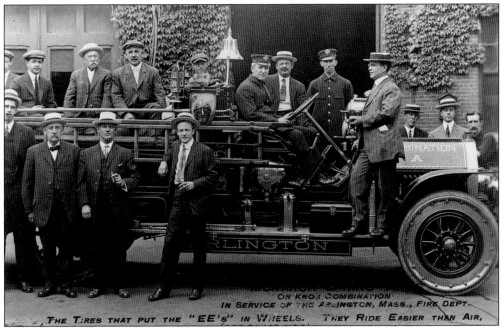

The Arlington Fire Department began to motorize its equipment in 1911 and within a couple of years, found itself featured in an advertising postcard for Monarch Spring Tires. Monarch claimed to put the "EE's" into wheels. This photograph appears to have been taken in front of the old Highland Station.

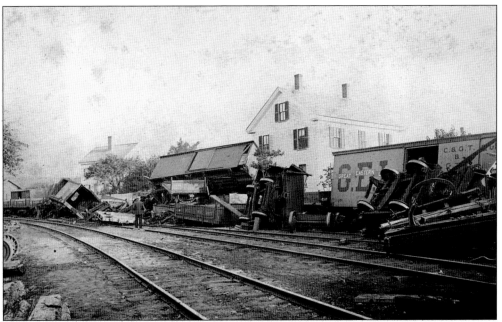

This spectacular boxcar pileup occurred in Arlington Center in 1912. The rail line was heavily used for both freight and passenger traffic in the early part of the 20th century, but records reveal only two serious train wrecks, neither of which involved passenger cars. Pedestrian injuries and deaths were, unfortunately, all too frequent over the years.

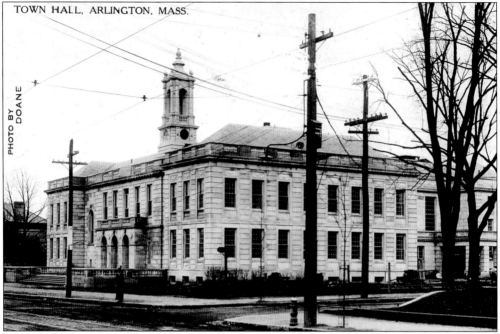

The Robbins Memorial Town Hall is shown under construction during the winter of 1913. The tower clock, fountains, and flagpole have yet to be installed. Advertising on the reverse side of this postcard reads: "For Expert Amateur Photograph Finishing, mail your films to New England's Largest and Best Equipped Photo Finishing House. DOANE, Arlington, Mass."

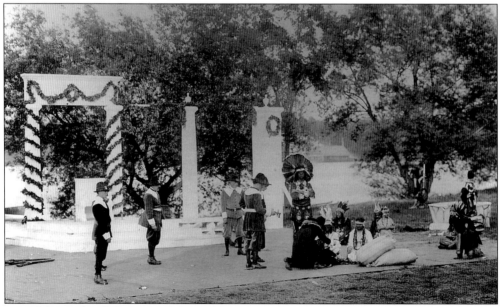

To celebrate the dedication of the Robbins Memorial Town Hall in June 1913, over 600 residents participated in a pageant of historical artistry (if not accuracy) on the banks of the Mystic Lake. This tableau depicts Squaw Sachem in 1635, deeding to English settlers upon her death the lands that would become Arlington and Winchester. Payment included one English cloth coat each year for the rest of her lifetime.

This beautifully detailed two-family residence at 21 Cleveland Street is typical of the size and style of housing that predominated during the years of East Arlington's explosive growth in the early 20th century. Swedish immigrant Karl Peterson built the home *c.* 1911. Many residents of Swedish descent settled in Arlington, and their social organization, the Viking Lodge, was quite active in community causes.

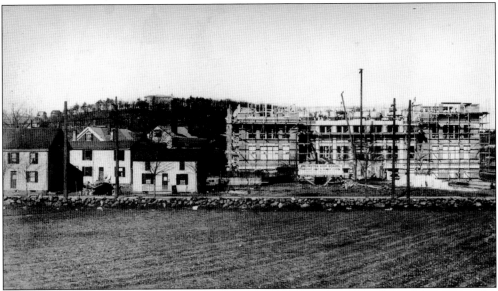

With new housing came the obvious need for new schools. Here, the nucleus of the present-day Arlington High School is under construction in 1914. Recently opened Symmes Hospital can be seen at the top of the hill. In the foreground are the fields of the Henry J. Locke farm, which was sold a decade later to create the "Lockeland" residential subdivision.

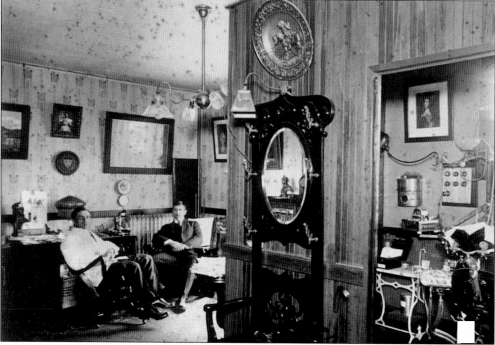

This interior shot of Dr. William Perry's dental office is dated 1917. The dental chair, sink, and instruments are visible through the doorway at right. Lighting appears to have been available by both electricity and gas. The shield in the round frame above Dr. Perry's head suggests that he was a Harvard graduate.

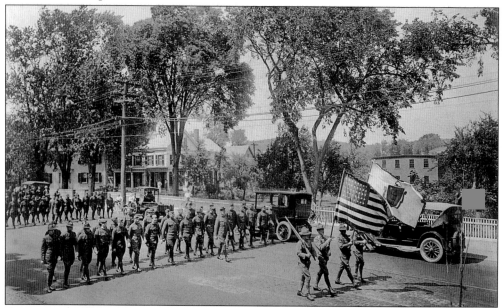

Veterans of World War I (then known as the "Great War") marched eastward down Massachusetts Avenue in a "Welcome Home" parade held in June 1919. Thirty citizens had been killed out of the 969 Arlingtonians who had served in the armed forces. Visible in the background, above the flags, is a portion of the Theodore Schwamb piano case manufactory.

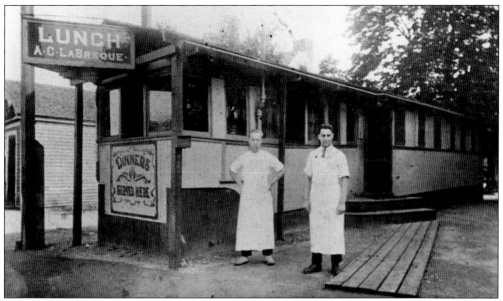

An unidentified cook or dishwasher, hands on his hips, seems reluctant to join Joe Paradis for this c. 1920 photograph taken in front of LaBreque's diner. Located close by the railroad crossing in Arlington Center, and curiously nicknamed the "Dog Cart," it was a beloved institution for decades.

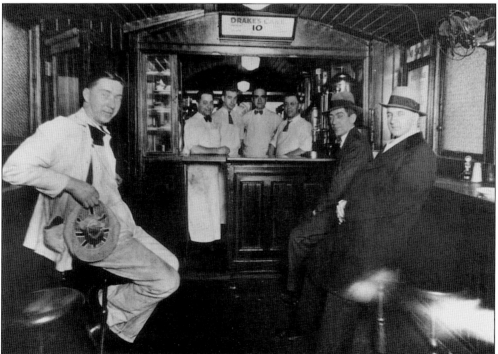

Charlie LaBreque's "lunch" cart in fact served meals late into the night—whether catering meals to doctors returning from their hospital rounds or for the ice-cutting crews on Spy Pond. In 1973, Joe Paradis recalled that the ice company "used to call us at the last minute for two or three hundred sandwiches and ten or fifteen gallons of coffee. And it kept us busy for awhile."

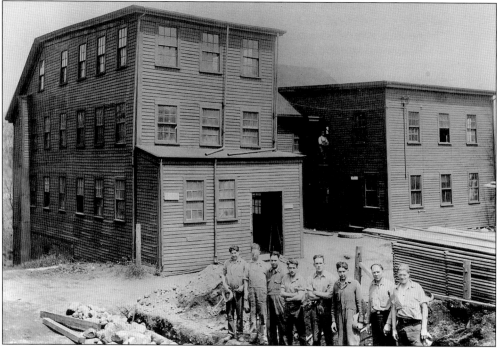

Workers pause in front of what is now the Old Schwamb Mill in 1923. The trench at their feet has been dug to accommodate a water pipe for the installation of the mill's first sprinkler system, which was rather more of a necessity than a luxury in a woodworking environment.

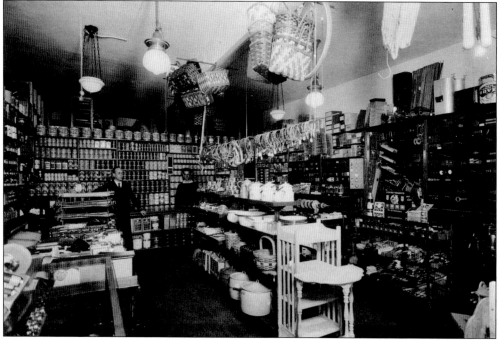

Chester Wanamaker, left, stands with Gerald Morgan, right, at the rear of his newly opened hardware store in 1923. Now in its third generation of family ownership, Wanamaker's Hardware qualifies as a true Arlington Heights "institution."

The Arl-Lex Orchestra was a three-girl band featuring Arlington residents Mabel Belyea on piano and Marguerite Rich (Kuhn) on violin and Lexington's Hazel Whiting on drums. A program of dances was printed on a dance card at the beginning of the evening; girls filled their card with the names of gentlemen from whom they had accepted an invitation to a two-step, fox-trot, or waltz.

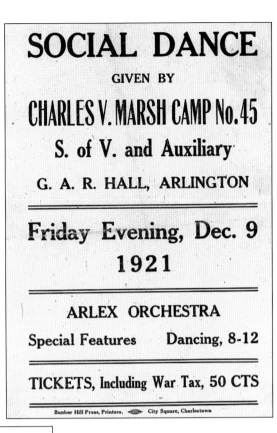

SOCIAL DANCE

GIVEN BY

CHARLES V. MARSH CAMP No. 45

S. of V. and Auxiliary

G. A. R. HALL, ARLINGTON

Friday Evening, Dec. 9
1921

ARLEX ORCHESTRA

Special Features Dancing, 8-12

TICKETS, Including War Tax, 50 CTS

Bunker Hill Press, Printers, City Square, Charlestown

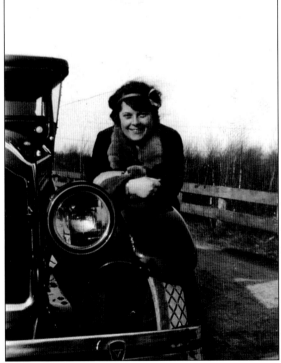

Marguerite Rich (Kuhn) lived all her life at 25 Avon Place, which still remains in the family after more than a century. Here, she is posing by her first automobile in 1924. Although a present from her father, the car was really not as extravagant a gift for the era as it may seem: her father did not have a driver's license, but he did have a lovely daughter who would graciously transport him in style!

31

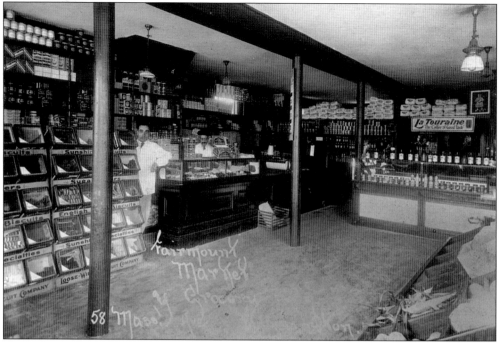

This 1921 view of the Fairmont Market and Grocery shows the interior of a typical "corner store" of the early 20th century. On the left is Caspar Tekmejian. Behind the counter is Avedis Avakian, whose family is believed to have been the first of many Armenian immigrants to settle in Arlington. (Project SAVE Armenian Photograph Archives/Courtesy Anahid Avakian.)

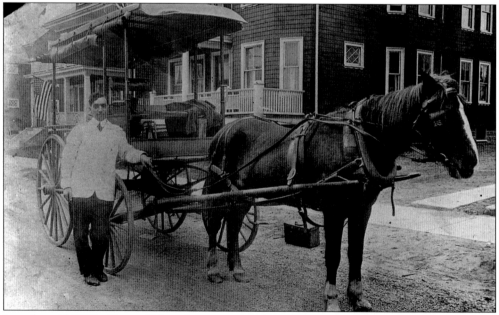

Into the mid-1920s, Caspar Tekmejian transported groceries to the homes of his East Arlington customers with his horse "Dolly" and this delivery wagon. The Fairmont Market was located at 58 Massachusetts Avenue, at the corner of Fairmont Street. (Project SAVE Armenian Photograph Archives/Courtesy Anahid Avakian.)

Two

1925–1949: Boom and Depression, War and Peace

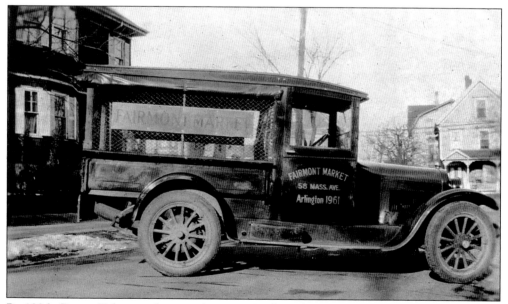

By 1926, Caspar Tekmejian's niece Armenie Avakian (Najarian) and her friends were using the Fairmont Market's old horse-drawn wagon as a backyard playhouse, for the truck shown here had taken over Dolly's delivery duties. Groceries were frequently home delivered until the 1950s, because so few families had cars. In the late 1990s, supermarkets began reintroducing home delivery services, targeting households with plenty of personal transportation but little personal time. (Project SAVE Armenian Photograph Archives/Courtesy Anahid Avakian.)

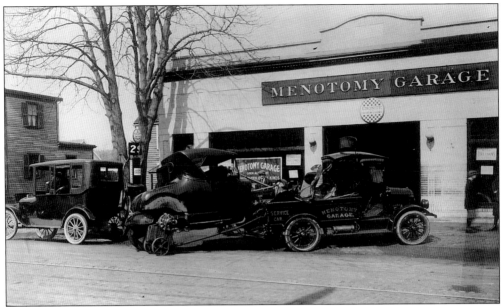

An early tow truck, labeled "Service Car," is transporting the remains of an automobile wreck back to the Menotomy Garage at 975 Massachusetts Avenue, c.1925. Notice the automobile at the left awaiting a curbside fill-up. The sign on the pump indicates a price of 29¢—the 1999 equivalent to almost $3 a gallon.

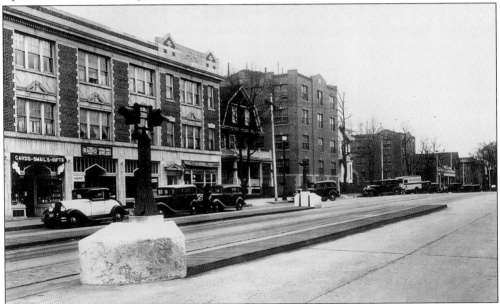

This c. 1929 view looking down Massachusetts Avenue, just west of Lake Street, captures the variety of changes in East Arlington in fewer than three decades. Seen here, from left to right, are the 1925 Locatelli commercial and apartment block (anchored by the Capitol Theatre, which is just out of range), a c. 1915 wood-frame home, and two five-story apartment buildings of similar vintage, between which one gets a glimpse of the 1855 mansion house of John Squire. In the foreground are the wooden platforms of the streetcar stop. (Society for the Preservation of New England Antiquities.)

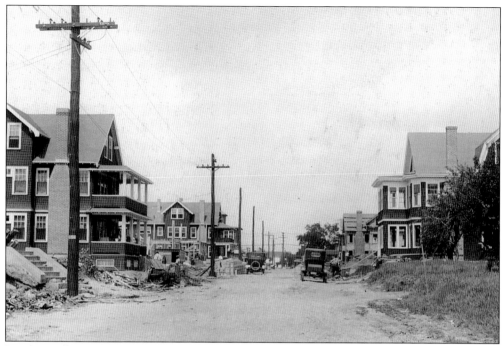

In 1926, Allen's Farm in East Arlington was subdivided to create a neighborhood of two-family homes for sale. Its newspaper advertising emphasized some curious marketing features, such as noting that the development was sited upon "fertile soil." Another selling point reminded prospective buyers that "[Street] Car fare is a major item of expense. Allen Gardens is in the ten-cent zone."

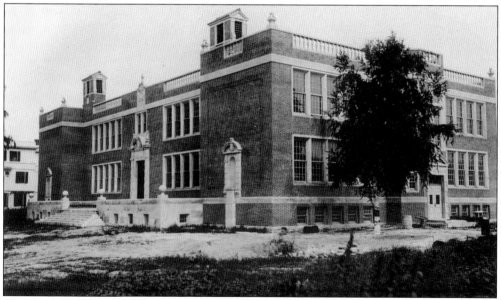

The St. Agnes Parochial Grammar School on Medford Street is nearing completion, in this 1925 photograph. Located on the site of some of Rawson's greenhouses, this 16-room brick structure replaced the 1880s wooden schoolhouse across the street. A top-floor addition was built in 1937. (*Boston Herald.*)

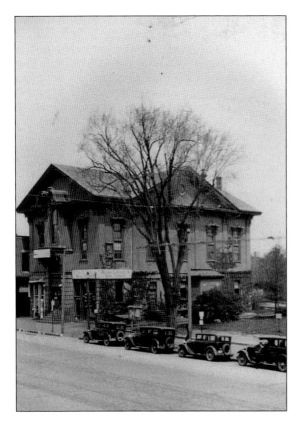

Arlington's old town house, built in 1852, was struck by lightning in 1923 and consequently was shorn of its picturesque rooftop lantern. Moving picture shows were held in its second-floor auditorium, prior to the construction of the Regent and Capitol Theatres. The building was razed in 1961 to make way for the new junction of Mystic Street and Massachusetts Avenue. The 1976 Uncle Sam statue and a small park occupy a portion of the old town house site. (*Boston Herald.*)

In 1927, the police department moved out of the ground floor of the old town house and into this purpose-built station at the corner of Central and Bacon Streets. A portly patrolman and a boy in his toy wagon impart the quintessential image of "keeping the peace." When the Arlington Police and Fire Departments moved to shared headquarters on Mystic Street in 1983, the old police station was converted to private office space. (*Boston Herald.*)

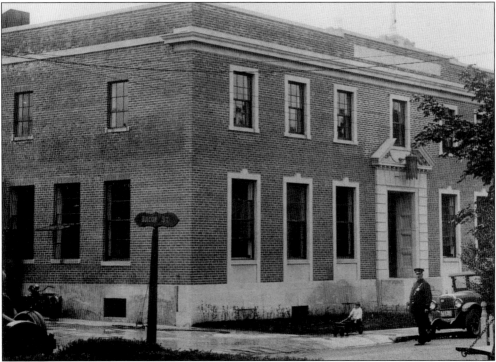

Dr. Edwin Stickney's house at 62 Pleasant Street was destroyed in the early 1970s to clear land for a new apartment building. The threatened loss of the adjacent 1830s Jarvis House galvanized concerned citizens to seek the formation of a historical commission. Arlington today has seven historic districts and protects other historically significant properties through its demolition-delay bylaws. (*Boston Herald*.)

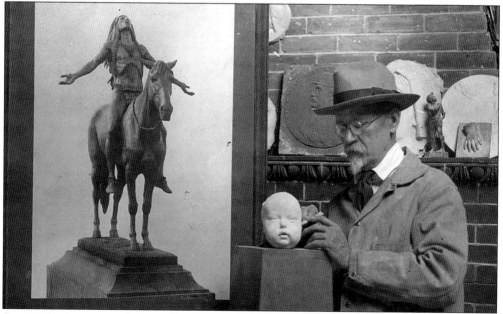

Seemingly far removed from the noisy progress of Arlington's growth was the Oakland Avenue studio of Cyrus Dallin, who had already achieved great fame as a sculptor when he made Arlington his home in 1900. A photograph of his *Appeal to the Great Spirit*, a sculpture commissioned for the front entrance of Boston's Museum of Fine Arts, can be seen in this image. Dallin died in 1944 and his studio burned to the ground only one year later, but his legacy thrives in an Arlington museum dedicated to his life and work. The museum, located at the Jefferson Cutter House, opened in 1998.

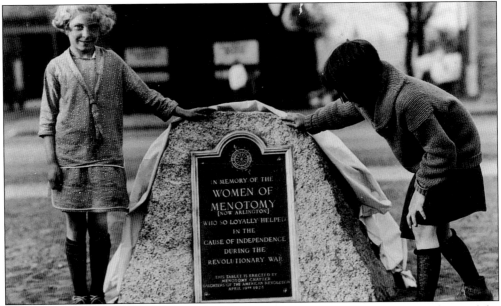

Two girls in stylish bobbed haircuts inspect the monument unveiled by the Daughters of the American Revolution on April 19, 1926. The monument honored the women of Menotomy (as Arlington was known in Colonial times) "who so loyally helped in the cause of independence." The constitutional amendment granting female suffrage in the United States was still quite recent, so feelings of pride in women's roles in American history were especially strong in the 1920s. (*Boston Herald.*)

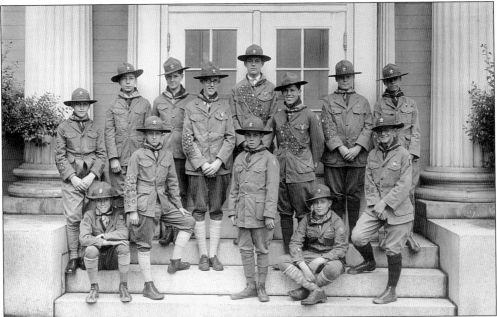

Scouting has been important to generations of Arlington boys and girls. Boy Scout Troop 8, based at the Orthodox (Pleasant Street) Congregational Church, seems to be especially proud of its many individual and collective accomplishments. Note the profusion of merit badges and the three Eagle Scout awards among this group of young men.

Baby Claire Sexton (Gibbons) takes some afternoon sun in her wicker baby carriage. The camera looks down Longfellow Road towards High Haith Road, two streets in a development begun in the late 1920s called "Park Heights." Although the name never stuck, this neighborhood and other nearby areas off of Highland Avenue quickly filled in with houses, which propelled the opening of the original Brackett School in 1931.

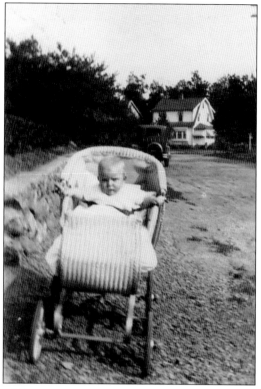

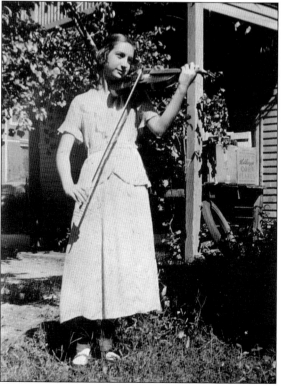

Anahid Avakian poses with her violin in 1932. There were so many children of Armenian descent in her East Arlington neighborhood that a private "Saturday School" of Armenian language and culture was run for them at the Junior High East (Gibbs). As an adult, she delighted audiences for decades as a professional violinist; she continues to entertain even in retirement. (Project SAVE Armenian Photograph Archives/Courtesy Anahid Avakian.)

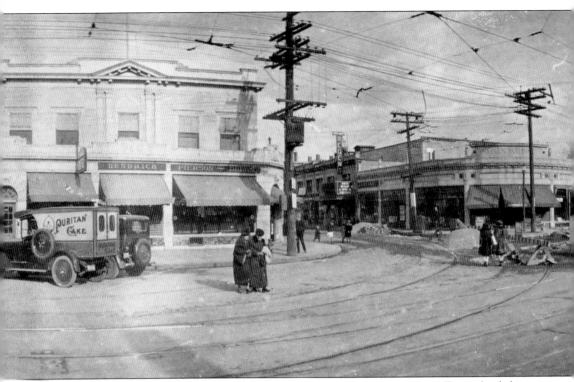

This panoramic view of Arlington Center captures it at an exciting time. From the left, we see a Puritan Cake delivery truck in front of the storefronts that wrapped themselves around the old Hiram Lodge Masonic Hall. After its 1924 fire, the Hiram Lodge received a handsome Colonial Revival exterior renovation. Hendricks gave way to the popular Mary Alyce Shop in the 1950s; Pierson Drugs later became Cole's and then Crisafi's Pharmacy. Today, it is the site of Arlington's first "Computer Café," a business where customers drop by to explore cyberspace and receive lessons in the art and science of personal computing.

On Medford Street, Hoffman's Regent Theatre, built in 1916, is showing the double-feature *White Desert* and *A Thief in Paradise*, enabling us to date this image to 1925. It was forbidden to show moving pictures on Sundays in Arlington until 1935. The curved Allen Building became home to the Nevaire Gift Shop for over 40 years, starting in 1955. Today, it is the location of one

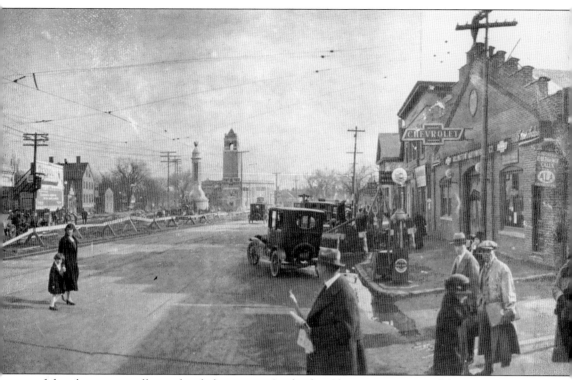

of the ubiquitous coffee outlets belonging to Starbucks. Close examination of the construction work on Broadway shows manual labor assisted by the horse-and-wagon. Above this activity rises a billboard advertising Oxydol laundry detergent.

Panning across the Civil War Monument (1887), the Central Fire Station seems to be nearing completion. At right, businesses on the south side of Massachusetts Avenue include the Monument Market. The Chevrolet logo of the Arlington Automobile Company extends from the façade of a distinctive step-gabled brick building. Located at 452 Massachusetts Avenue and constructed as Arlington's first automobile service garage in 1909, the building is perhaps best remembered today as the home of the very first Pewter Pot Muffin House. Although the individual businesses have turned over several times through the decades, it is interesting to see that the general massing of this major streetscape has changed very little in the last 75 years.

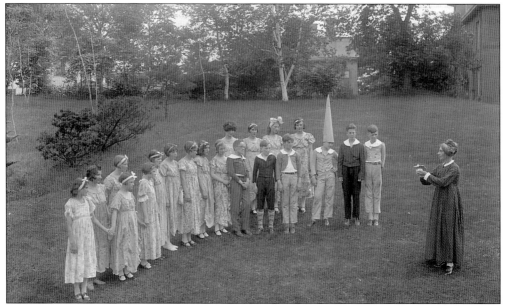

Arlington celebrated the 1930 Tercentenary of the establishment of the Massachusetts Bay Colony in extraordinary style. "A Pageant of Music in America" was staged and included this depiction of an early 1800s schoolmarm and her students. It is unknown whether the boy is wearing the dunce cap for poor classwork or an inability to carry a tune in this scene!

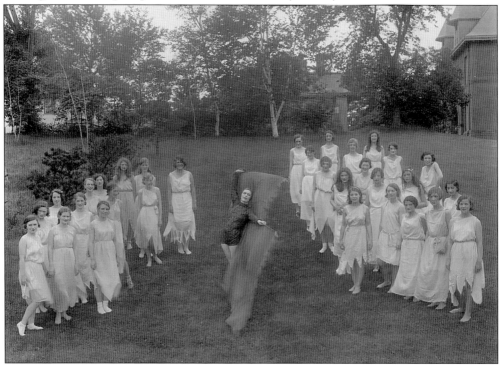

The actual pageant was performed in the pouring rain, so it seems as if the photographs of it were taken during dress rehearsals. This scene from the prelude featured the "Sprits of Nature," "The Flame," and "Voices of the Wind."

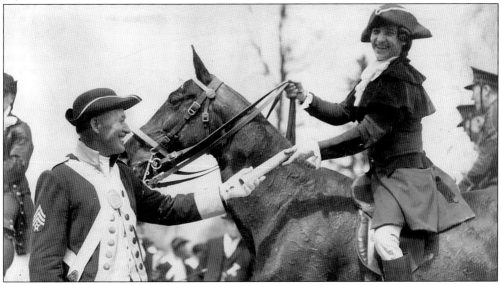

"Paul Revere" stops in Arlington on his way from Boston to Lexington in a reenactment of the midnight ride of April 19, 1775. Unlike the original ride, the stops along the route were met with pomp, ceremony, and some fortifying Colonial brew! As Prohibition was in force in 1930, it is unknown exactly how this Revere managed the last leg of his journey.

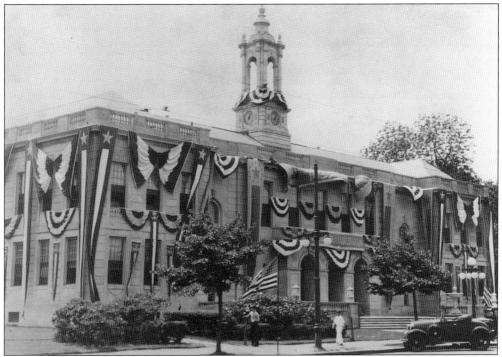

The Arlington Town Hall is festooned for the Tercentenary events in June 1930. Its appearance on Massachusetts Avenue is little changed today from its original 1913 design, because the 1950s annex projects only from the rear façade. A carved stone pineapple surmounts the open lantern above the clock, the fruit motif representing New England's traditional symbol of welcome. (*Boston Herald.*)

In June 1934, an electrical storm damaged the Arlington Town Hall. It was pointed out to a newspaper reporter from the *Boston Traveler* how a bolt of lightning had blown to bits the beloved pineapple at the top of the lantern. Not being able to see for himself what exactly was missing from the building, and thinking that surely he must have misunderstood the locals, the reporter wrote of the destruction of the "pinnacle" instead of the "pineapple." (*Boston Herald*.)

The Arlington Post Office moved into a building of its own on Court Street in April 1936. The Colonial Revival structure was a Depression-era construction project of the Works Project Administration (WPA), which put great numbers of America's unemployed to work on building government facilities. An original mural by a WPA artist adorns the inside lobby. (*Boston Herald*.)

The WPA built this step arrangement in 1937 at the corner of Dundee Street and Argyle Road in Arlington's "Little Scotland" section of the Heights. Before the Federal reemployment program, "jobless relief" was organized out of the Old Town House, giving irregular work assignments like snow shoveling for $3 daily pay; the local welfare bureau distributed food and clothing from offices in the Whittemore-Robbins House. Arlington's unemployment peaked at just under 20% in 1934. (*Boston Herald*.)

The Great Hurricane of 1938 felled many trees, but it spared the Arlington's first meetinghouse, shown here at 208 Pleasant Street. Built in 1734, the meetinghouse was moved in 1804 to what is now the corner of Lombard Road and converted to a residence. It traveled southward again in 1850. Finally, it was razed in 1957 to make way for a modern home.

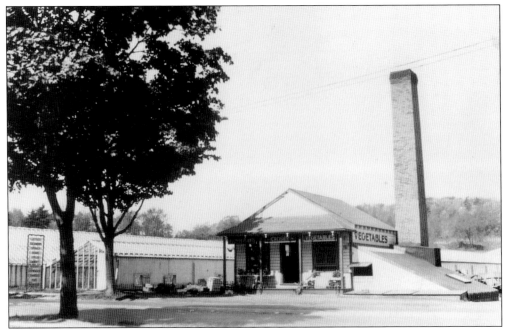

The Crosby Farm on Mystic Street was the last major market garden operation in Arlington. This view of its farm stand and some of its greenhouses was taken in 1939. After 1957, this building was enlarged to become a residence, still bearing number 228 Mystic Street.

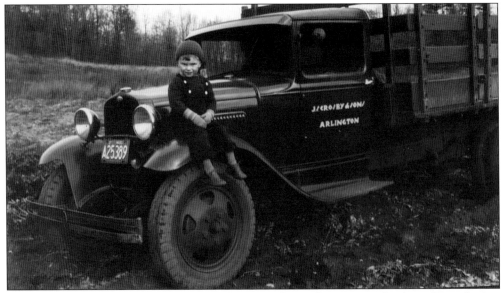

Donald Bennett, a grandson of John Crosby, spent his early years on the farm. Here, he has posed upon the hood of the farm truck in the 1930s. Much of the produce grown was sold at the wholesale markets of Boston; Crosby's "pure white" celery was famous for its quality.

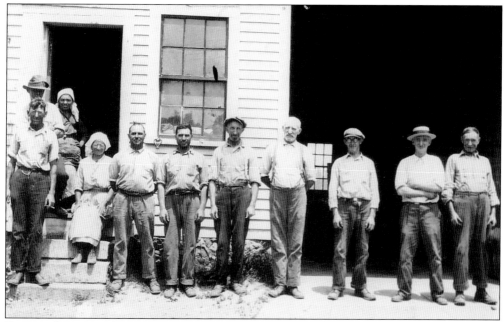

Farm workers pause for a cheerful snapshot on the Crosby Farm. Most were Italian immigrants, some of whom spent their entire working lives at Crosby's after arriving in the United States. The women usually worked only during the harvest months, but the men were kept busy year- round. Their working days started at 6:00 a.m., followed by a lunch break at 9 o'clock. Afterwards, it was back to work until the noon meal and rest hour. The afternoon ended at 5:30 in winter and a bit later at summer's peak.

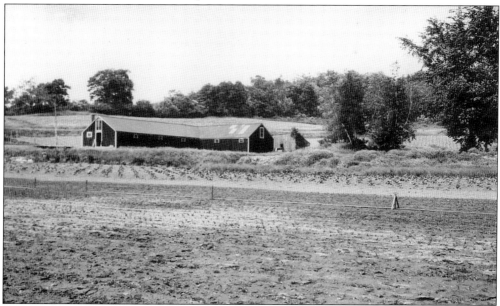

This view shows the piggery at Crosby Farm; it was a preferred place to work in the winter because it was heated. A large section of the farm was sold for residential development in the lower Ridge Street area in 1936. Commercial agriculture in Arlington came to an end in 1957 when the rest of Crosby Farm was subdivided for housing.

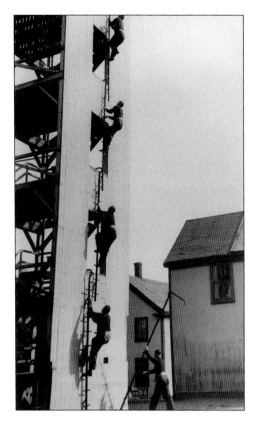

Arlington firefighters, engaged in a scaling ladder drill in 1933, make their way to the top of the practice tower. Notice the old-style tool held by the fireman on the ground, from which the term "hook and ladder" is derived. (*Boston Herald.*)

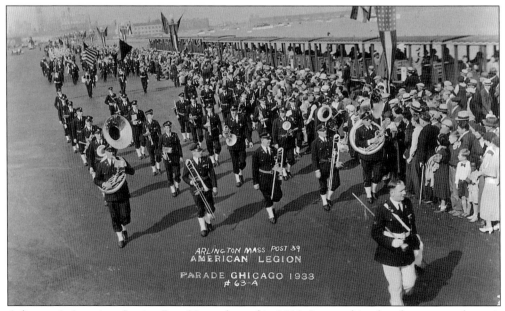

Arlington's American Legion Post 39 was formed in 1919. Its marching band was a popular unit at all local parades; it even performed on a trip to Chicago in 1933.

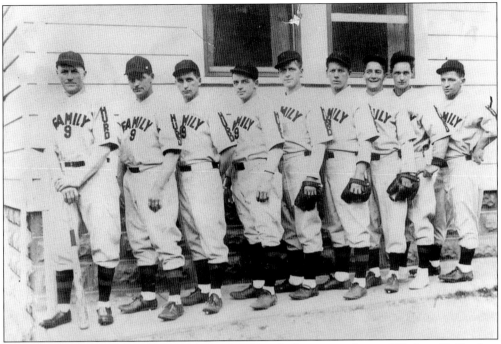

"The Hurd Family Nine" was a semiprofessional baseball team, made up of Herbert C. Hurd and his eight sons. The Heights family of hitters were a regional phenomenon in the 1930s.

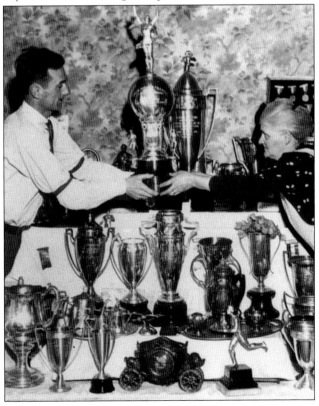

Johnny Kelley, with mother's help, arranges some of his many running trophies at their Arlington home. A 1927 graduate of Arlington High School, the legendary Kelley ran the Boston Marathon 61 times. He wore the laurels twice, in 1935 and 1945, and represented the United States in the 1936 Olympic Games. (*Boston Herald*.)

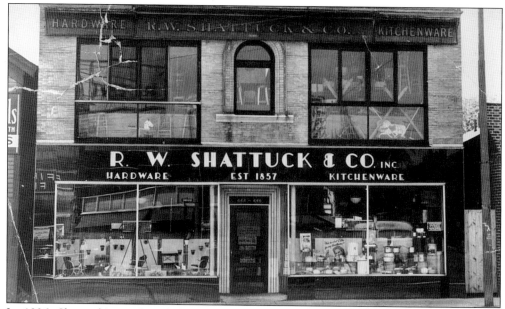

In 1936, Shattuck's purchased the Renaissance Revival Fowle Block at 444 Massachusetts Avenue and remodeled it in the art deco style that was then at its apex.

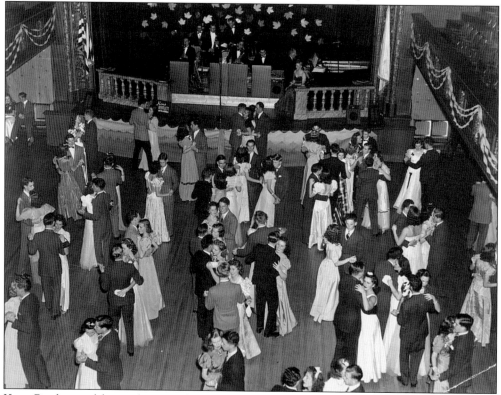

Kent Bartlett and his orchestra, whose female vocalist is seated on stage by the ornamental balustrade, provided the swinging sounds for the 1940 Harvest Hop held by the Arlington High School Dramatics Club in the town hall auditorium.

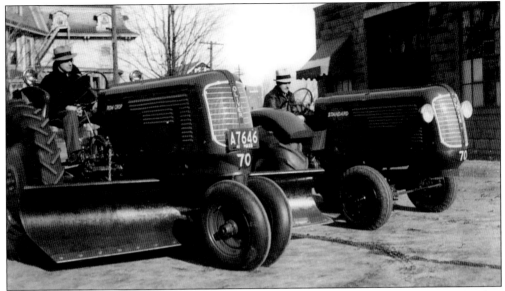

After selling off a portion of their farmlands in 1936, members of the Crosby-Bennett families of Mystic Street operated an Oliver Tractor concession at 17 Prescott Street. The tractors were outfitted with snowplows, intended for delivery to the East Boston (Logan) Airport, where they helped to keep runways clear in the early years of modern commercial aviation.

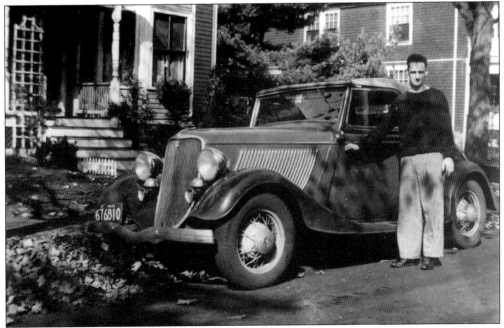

Walter Hurd was among the 4,817 Arlingtonians who served in the military during World War II. Six weeks after being awarded the purple heart, he returned to active duty and was killed in action in France on October 31, 1944, at age 29. A total of 107 servicemen sacrificed their lives between 1940 and 1945.

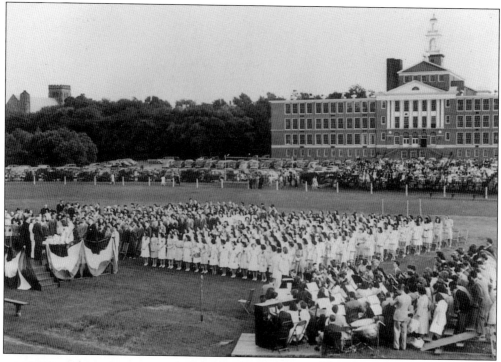

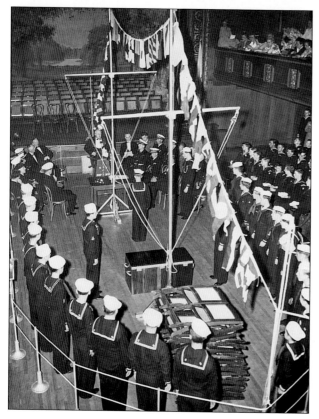

The 1942 graduation exercises for the Arlington High School took place in Peirce Field. Notice the absence of caps and gowns in those days. Instead, boys were attired in business suits, and girls wore white or pastel daytime dresses with white high-heeled shoes. (*Boston Herald.*)

With more and more boys and girls heading into military service, other graduation ceremonies were held in Arlington during WWII. This one was for the Sea Scouts in 1944. The floor of the Arlington Town Hall auditorium was cordoned off in the form of a ship, complete with masts, signal flags, sea chest, and a wheel bearing the insignia "Ship No. 37."

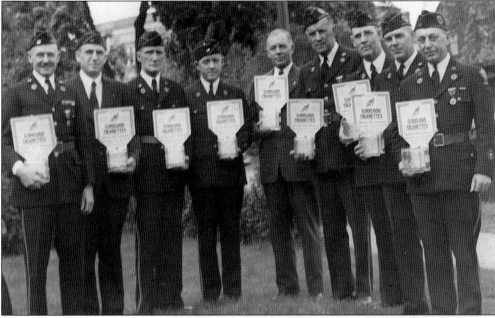

Local veterans pose with coin collection boxes at the start of their 1944 fund-raising campaign to supply 5 million cigarettes for "service men overseas." Cigarettes were a part of every soldier's ration kit, and those who didn't smoke found them useful as bartering tools among their buddies or to make purchases in the local economies where they were stationed.

The shortage of nurses during WWII meant that volunteer aides were in tremendous demand at Symmes Arlington Hospital, where they received a six-week training course to perform basic patient care and related duties. In this contrived publicity shot, a group of young aides folds linens under an attentive supervisor from the Arlington Visiting Nurses Association.

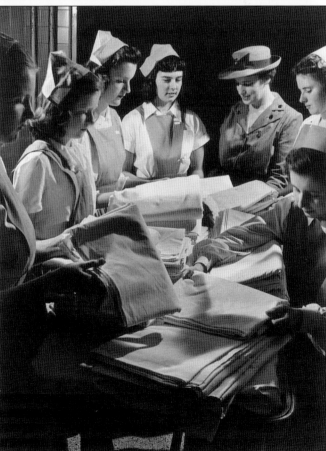

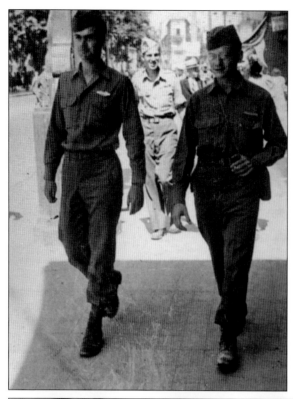

Ralph W. Sexton of Arlington, left, and his army friend Bernard Murowchick are taking a stroll in Marseilles, France, in June 1945. Street photographers captured many similar images for servicemen to purchase and send home. The war had just ended in Europe and the men were expecting to ship out to the Pacific Theatre; those orders were soon canceled when the Japanese surrendered.

Zadig "Harry" Fantazian's Barber Shop was located at 1191 Massachusetts Avenue in the Heights. Fantazian is waving to the camera from behind the shop window in 1948. Gathered outside are, from left to right, his daughter Nancy, his son Jim, his niece Acabie Guiguizian, his sister Markarid Guiguizian, and his fellow barber Sam Hanoian. (Project SAVE Armenian Photograph Archives/Ojen Davidian Fantazian.)

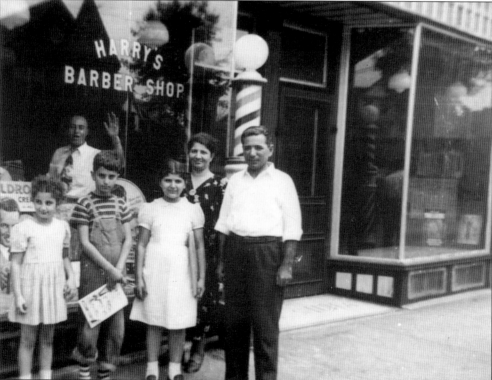

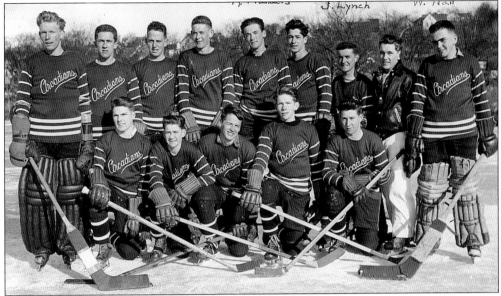

Sporting events resumed with particular vigor at the war's end. Here's a portrait of the Arlington Arcadians hockey team taken on Spy Pond during their 1945–46 championship season in the Old Colony League.

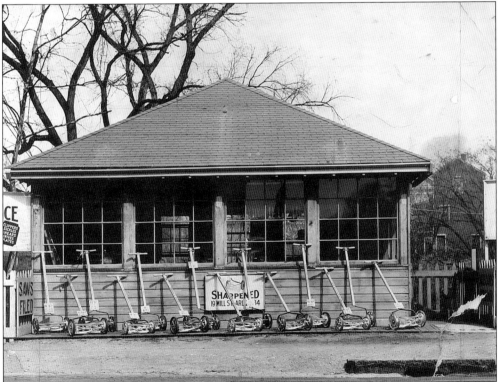

Zwicker's was a simple little shop at on the banks of the Mill Brook at 19 Mill Street, but it was famous for having the skate-sharpening concession of the Boston Bruins hockey team. In the warmer months, it kept busy with lawn mower sales and the honing of blades of all descriptions.

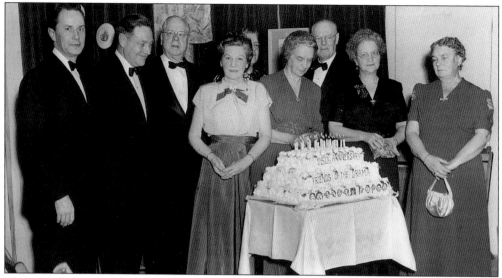

With the darkness of the war years now past, it was again easy to celebrate the pleasures of life in Arlington. These elegant folk have gathered in 1948 for the 25th anniversary of the Friends of the Drama. To celebrate its 75th anniversary in 1998, the thespian group recently completed a historically sensitive renovation of its Academy Street playhouse.

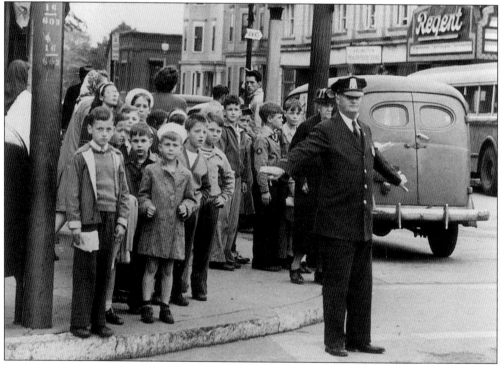

With wartime gasoline rationing soon to be a thing of the past and lots of new babies around, police officers had to contend with much more traffic in the streets and on the sidewalks. This picture was taken at the corner of Massachusetts Avenue and Medford Street. This intersection became less busy once Mystic Street was realigned in 1962 to permit through traffic coming from Pleasant Street. (*Boston Herald.*)

56

Three

The Order of Saint Anne and Its Legacy

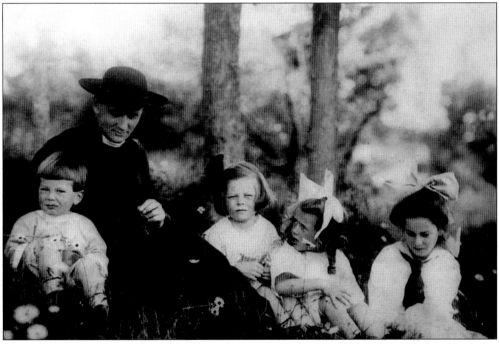

The Reverend F.C. Powell, "Father Founder" of the women's religious Order of Saint Anne, spends a quiet moment with children cared for by the Sisters at their Arlington hillside orphanage, c. 1915. The Episcopal Order traces its beginnings to the simple home of Ethel Barry at 181 Appleton Street, later known as St. John's Guest House, where she ran a Sunday school for children in the early years of the 20th century. Devotional services were conducted in a small wooden chapel erected in the backyard.

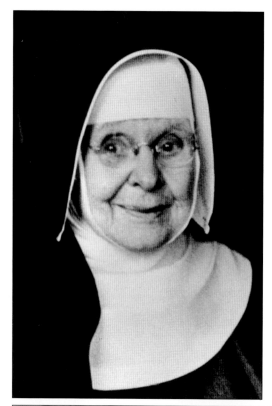

Ethel Barry's work expanded to a mission dedicated to the complete care of children who had been orphaned or otherwise left without a proper home and was formalized as part of the new convent in 1910. As the first Superior of the Convent, she became thereafter known as Mother Etheldred. Here, she is shown in the original 14th-century habit of the Sisters, with white wimple and coif, black veil, and gray surplice.

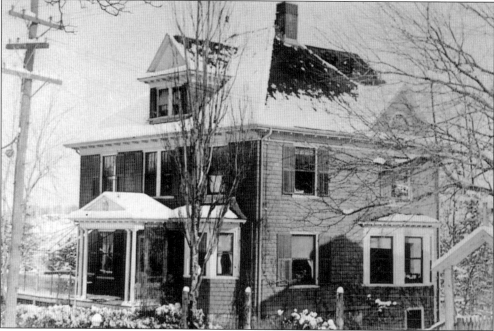

Having quickly outgrown St. John's House, two other houses were promptly acquired around the corner: 16 Claremont Avenue in 1910 and 18 Claremont Avenue (the present St. Joseph's Convent, shown here) in 1911.

St. John's Home for Children operated on a vastly different basis than other orphanages of the era. The children lived in small groups and each was treated very much as an individual. Boys typically stayed until their early teens, when they left to apprentice a trade; girls remained through high school, before leaving for office jobs, nursing training, or college.

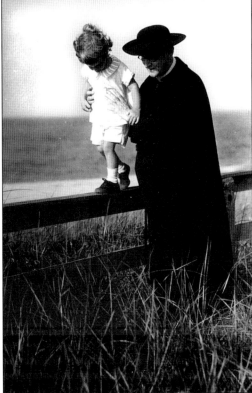

Father Powell of the (Episcopal) Society of St. John the Evangelist had a great love for disadvantaged children, one of whom he is tenderly accompanying for a walk during an outing to the seashore.

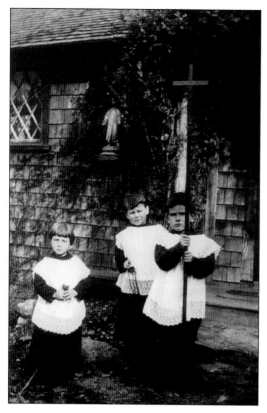

Three boys who had come to live at St. John's House for Children pause in their acolyte's garb in front of the old wooden chapel during a *c.* 1913 procession.

ST. RAPHAEL'S HOSPITAL ✠

FLOOR PLAN

In 1915, an additional lot of land was acquired to build this small wooden infirmary known as St. Raphael's Hospital. A necessity in the "prevaccination era" when measles, whooping cough, scarlet fever, and other communicable childhood diseases occurred frequently, its isolation function was also valuable during the terrible the 1919 influenza epidemic.

A far greater change in the landscape of the convent grounds also occurred in 1915, when the small wooden chapel was replaced with a handsome stone structure designed by prominent architect Ralph Adams Cram. The original interior plan, featuring many superb medieval relics, can be seen in this evocative view.

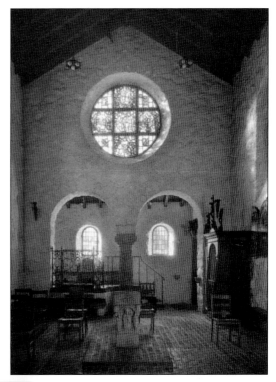

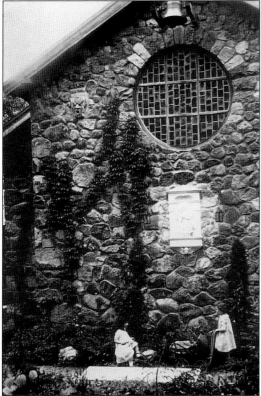

Two girls play beneath the east-facing round window outside the Chapel of St. Anne.

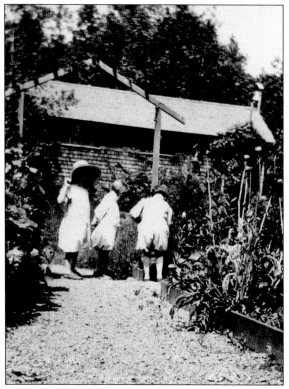

Children help to tend to the vegetables grown in raised beds on the convent grounds. The orphanage was largely self-sufficient for many of its fresh produce and dairy needs. In the early years, cows were kept for milk and for manure for the gardens. There were large fruit orchards and even a couple of pigs.

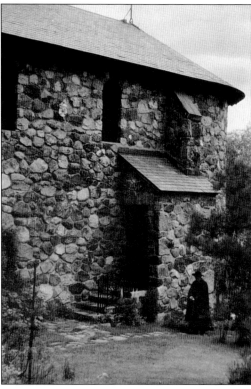

Father Powell mounts the hill path next to the chapel, in a scene reminiscent of a rural village in England.

Smoking was never permitted, but playfulness was certainly encouraged!

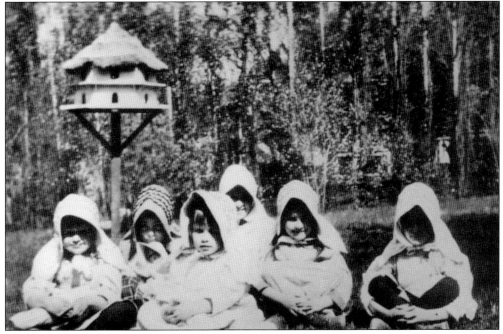

Running contrary to the practices of other orphanages of the era, the children did not wear institutional uniforms. Nonetheless, sunbonnets were essential "equipment" for little girls wishing to play in the sun. The children are posing on the lawn in front of the convent's dovecote.

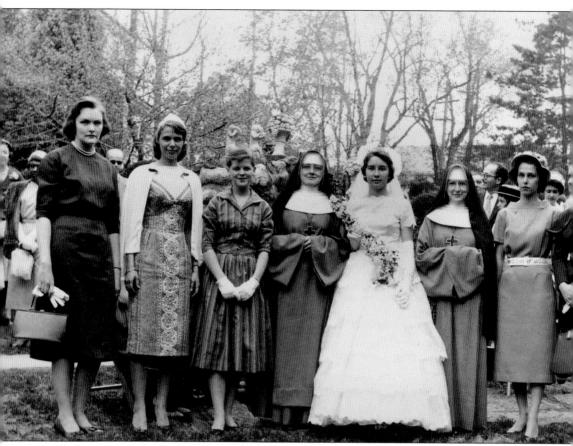

As the years evolved, the Sisters felt that it was better for the children to be educated at an on-campus school. Thus, they began to accept only girls and formally reestablished St. John's Home for Children as St. Anne's School in 1928.

During its half century as a girls boarding school, the May Day Procession, in honor of the Blessed Virgin Mary, became an important campus tradition. Small children danced around the maypole, and a senior girl was selected as the May Queen. Elpiniki Fountas held that honor in 1959, and was flanked on the left by Sr. Anne Catherine and on the right by Sr. (later the Reverend) Jean Sproat. Former May Queens complete the grouping. Sr. (now Mother) Christopher is behind the camera.

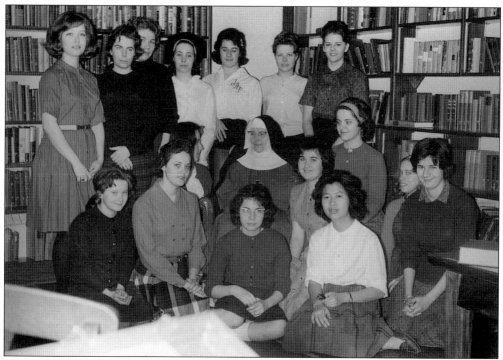

The students belonging to St. Anne's Guild pose with their sponsor, Sister Ruth, in the library. During the 1961–62 school year, membership in the guild ranged from grade 7 through grade 12.

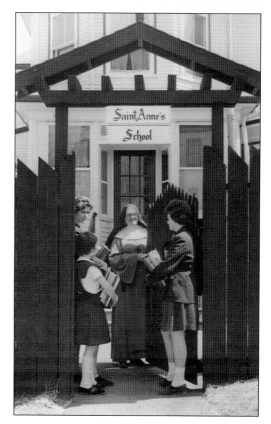

Mother Germaine is greeting Marilyn Manchester, Joyce Bergstrom, and Edith Mahler at the front gate in this 1965 image. St. Anne's was primarily a boarding school with only a few day students. It carried on the Sisters' mission of specializing in growth and education in a homelike setting. Frequently, one or both of a student's parents would be unavailable due to an overseas work assignment or serious illness in the family. St. Anne's also worked with students needing special educational attention.

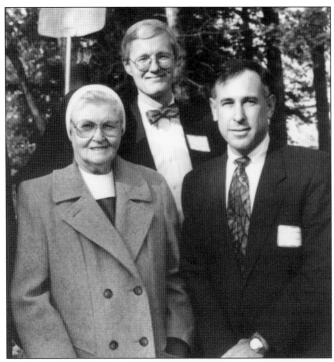

The late Mother Germaine was pivotal in the transition of St. Anne's School to an independent residential treatment facility for adolescent girls in 1980. Government programs for children had shifted from institutional to clinically intensive community settings, and the time had come for the Sisters to withdraw from the active management of a school. Here, Mother Germaine attends the 1993 ground breaking for a new building at the new school. In the center is Wesley K. Blair of Arlington, chairman of the Board of Germaine Lawrence, Inc.; David Hirshberg, executive director, stands at the right.

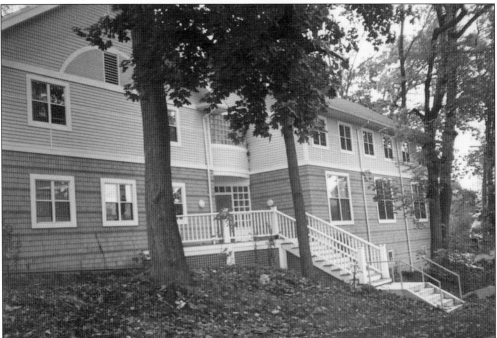

This rear view of the Jane Addams Treatment Center shows its architectural sensitivity to the historic landscape. This was the first new building created specifically for treating emotionally troubled girls. Although no longer formally affiliated with the Order of St. Anne, Germaine Lawrence, Inc. is a modern-day legacy of Mother Etheldred's concern and caring for children in need. It celebrates 20 years of success stories in the year 2000.

Four

Greetings from Arlington: Postcard Views

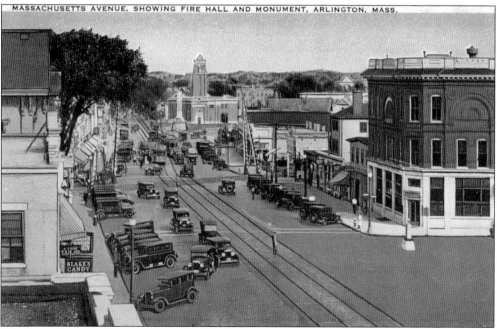

MASSACHUSETTS AVENUE, SHOWING FIRE HALL AND MONUMENT, ARLINGTON, MASS.

This linen-finish color postcard shows Massachusetts Avenue looking east, c. 1932. Note the three-story building of the Arlington Five Cents Savings Bank on the corner of Pleasant Street, which was torn down in 1956 for the current replacement, which has been home to Cambridge Savings Bank branch since 1991.

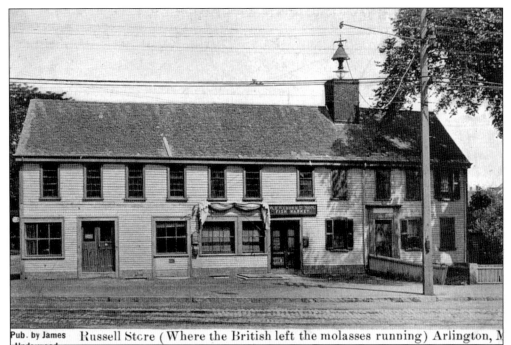

Pub. by James Russell Store (Where the British left the molasses running) Arlington, M

Located at the corner of Massachusetts Avenue and Water Street, the Russell Store was the site of a picturesque act of vandalism during the British soldiers' retreat to Boston in 1775. The store had already been vacated for the building's destruction in 1906 when this picture was taken. This postcard remained a best-seller long after a new brick commercial block was sitting in place of this Revolutionary War landmark.

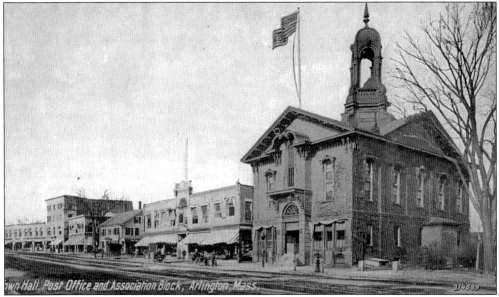

wn Hall, Post Office and Association Block, Arlington, Mass.

Still in active municipal service when this view was made, the 1852 Arlington Town Hall proudly bears the crown of its wonderful open lantern. The waving flag has been painted onto the pole. The "Association Block" is a misspelling for the four-story Associates Block, whose two-story extension at the far left replaced the old Russell Store in 1907.

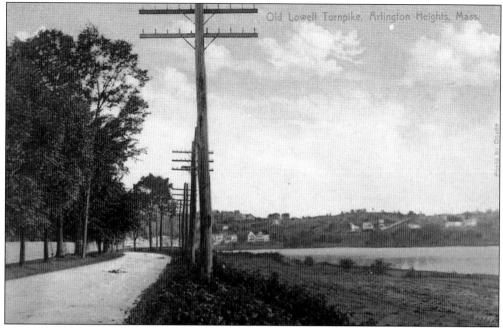

This view shows the Lowell Turnpike, an old county road now known as Lowell Street. The Arlington Reservoir can be seen at right. In the early 1950s, this scenic roadway was slated to become part of a six-lane extension of Route 3, but after vigorous citizen protest, this plan was abandoned in 1954.

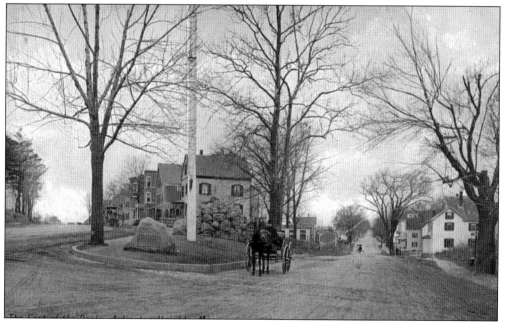

The Foot of the Rocks, at the junction of Massachusetts Avenue, left, and Lowell Street, was the site of a battle between the colonists and the British soldiers retreating from Concord and Lexington on April 19, 1775.

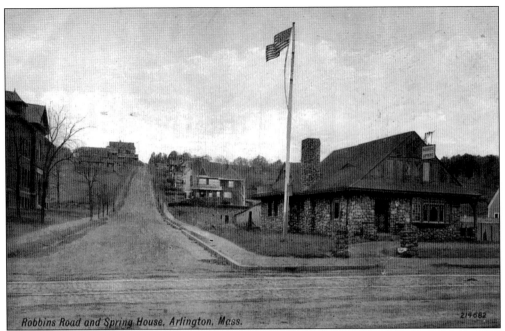

Robbins Road and Spring House, Arlington, Mass.

The Robbins Spring House on Massachusetts Avenue was the headquarters for a pure bottled water company by that name. It was remodeled as a residence in the 1920s. At the left is the Cutter School (now condominiums), and high on the hill was the Robbins Spring resort hotel, which operated until 1911. Thereafter, it was home to Marycliff Academy until 1949.

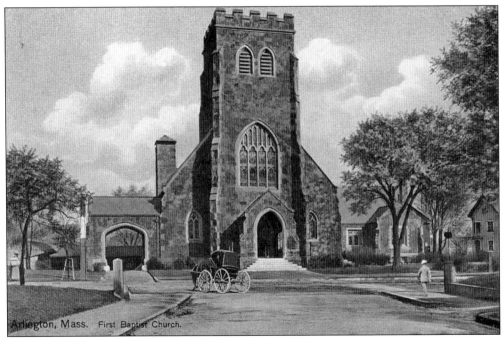

Arlington, Mass. First Baptist Church.

The First Baptist Church building, shown here, was dedicated in 1902. The Gothic stone structure replaced the 1853 wooden church on the same site, which burned on July 25, 1900.

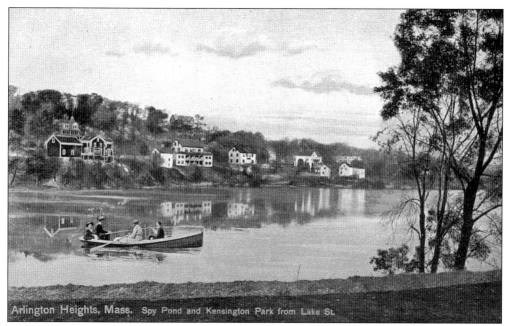

Arlington Heights was well known in the early 20th century as a lovely resort area. Its fame apparently misled one postcard manufacturer to conclude that all the beauty spots in town were located there. Here is a view of Spy Pond, located just south of Arlington Center. The people and the boat were added to the photograph later by an artist, which is why they appear to be out of scale with their surroundings.

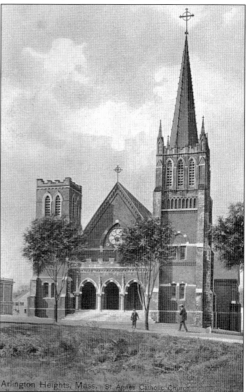

St. Agnes Church in Arlington Center was also misidentified as being located in the Heights. It changed its name from St. Malachy's in 1900 in a rededication that coincided with its enlargement that year. Two new towers and a Gothic-arched porch were designed for the front façade by Howard B.S. Prescott, the Jason Street architect of the 1914 Arlington High School.

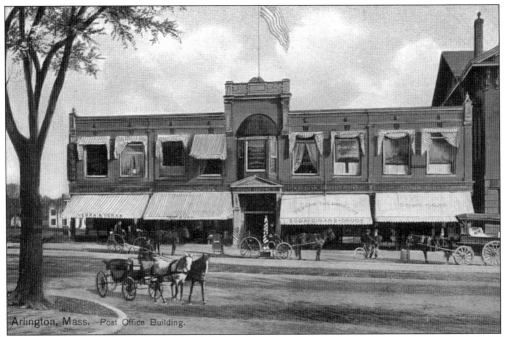

The Sherburne Block was Arlington's most exciting new building in 1900, since it had just been completed the year before. Access to the post office was through an impressive center entrance leading to the lobby toward the rear of the building. This arrangement was also conveniently close to the railroad station. The building lost its roofline center parapet in the early 1960s but is still standing today, next to the "Uncle Sam Park."

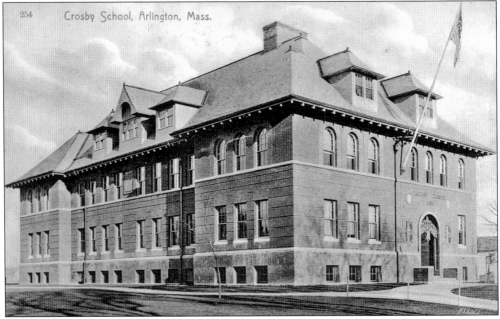

East Arlington's Crosby School was built on Winter Street in 1895, added onto in 1910, and rebuilt (minus its third floor) after fires in 1950 and 1954. It was closed, along with the Parmenter School, in 1983.

72

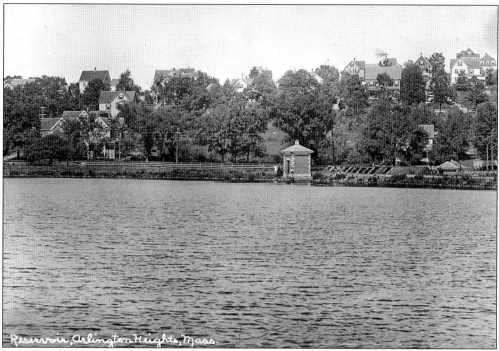

By the beginning of the 20th century, the 1873 reservoir at the Heights had already ceased operations as the town's water supply; it later became a recreational beach facility. Note the old brick pumping station on the shore. Rising above Lowell Street, many of the homes that make up today's Mount Gilboa Historic District can be seen.

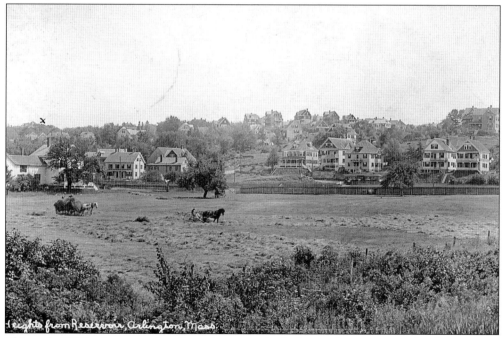

This early-1900s view was taken from the reservoir. It depicts farmers engaged in hay mowing in a nearby field.

Spy Pond Field, located between Lombard Terrace and Spy Pond, was the first purpose-designed athletic field owned by the town. A gift of Henry Hornblower of Pleasant Street in 1910, the field was quite convenient to the old Academy Street High School and later to the Junior High Centre.

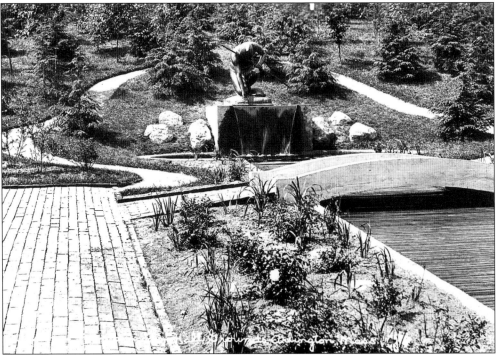

The Menotomy Indian Hunter statue by Cyrus Dallin is shown amidst the original 1913 landscape of the Robbins Memorial Garden, located next to the Arlington Town Hall. The gardens today are receiving renewed attention and funding to optimize their important contribution to the beauty of Arlington's "Civic Block."

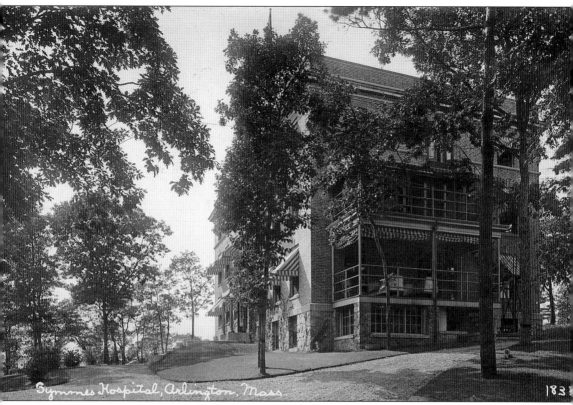

Symmes Hospital, Arlington, Mass.

183

This rare postcard view of Symmes Hospital is especially interesting because it shows its open-air porches, complete with rocking chairs and daybeds for convalescing patients. It bears a postmark of September 28, 1918—the midst of the worldwide influenza outbreak. The sender's own words convey the devastating impact that this illness was having on Arlington:

Dear Lulu, How's school? I haven't any now as it has been closed on account of so much sickness. It is <u>awful</u>. I do hope it won't get as far as Maine. The hospitals are all full and there aren't <u>anywhere</u> near enough doctors and nurses. Katherine is up at our little hospital now helping, and mother is going this P.M. The weather has been fierce but now it is great so I guess that will help as much as anything. This is a side view of our hospital. I wish I had a front one to send you. I do hope you are enjoying school. I expect to go back by Wednesday. Love, Catherine.

This postcard documents the heavy damage done to shade trees along Hillside Avenue following a severe ice storm on November 30, 1921. Photographers captured current events such as this and then sold the images as postcards ("a dollar a dozen") to neighborhood residents. It was a convenient way to share the latest local excitement with faraway family and friends.

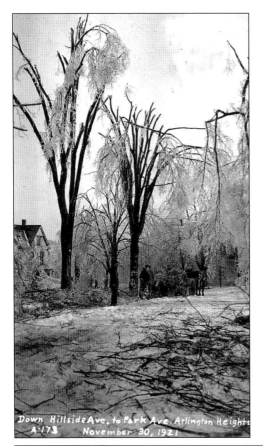

Down Hillside Ave. to Park Ave. Arlington Heights
A-173 November 30, 1921

Another catastrophic greeting card shows the 1924 fire-damaged Masonic Lodge at the corner of Massachusetts Avenue and Medford Street. Note that Pierson's Drugstore featured "college ices," as ice-cream sundaes were then called, among its soda fountain treats. The parking notice on the utility pole is quite wordy by modern standards: "Restricted Area. Must not stand more than 20 minutes. Park vehicles at an angle of 45 degrees with curb."

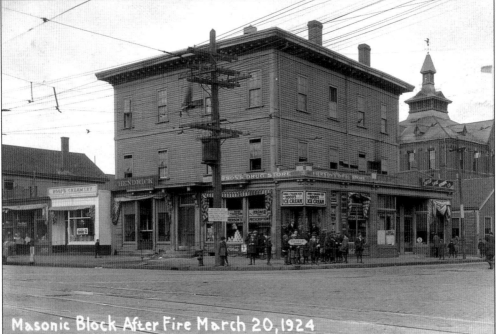

Masonic Block After Fire March 20, 1924

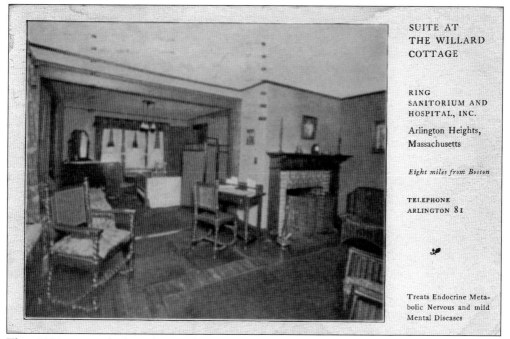

This 1923-postmarked card provides a rare glimpse inside a patient's accommodations at the Ring Sanatorium and Hospital. At this time and for many years afterwards, it operated its own training school for nurses. When the sanatorium opened in 1888, it was in a fairly isolated section of town. The neighborhood grew more residential over time, and the nearby homeowners' opposition to Ring's modernization plans led the facility to close in the 1950s.

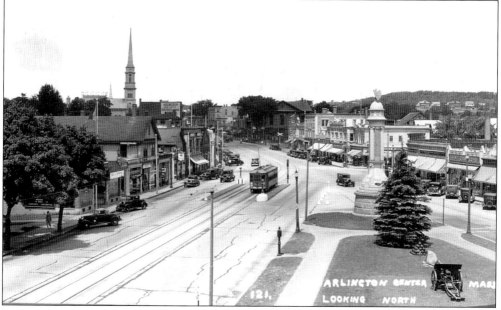

This view was taken from the Central Fire Station, looking west (not north) towards Arlington Center, *c.* 1930. Buses had recently replaced streetcars on the Broadway streetcar line, but the trolley continued in service on Massachusetts Avenue until 1955.

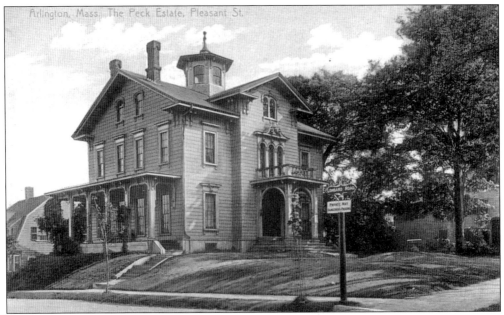

The Italianate mansion house of Abel Peck was one of the most picturesque homes in Arlington. It was from this girlhood country home that Peck's daughter, Angeline, moved across the road to number 87 Pleasant Street, following her marriage to J.Q.A. Brackett. She became "First Lady of the Commonwealth" when her husband was inaugurated the 32nd governor of Massachusetts in 1890.

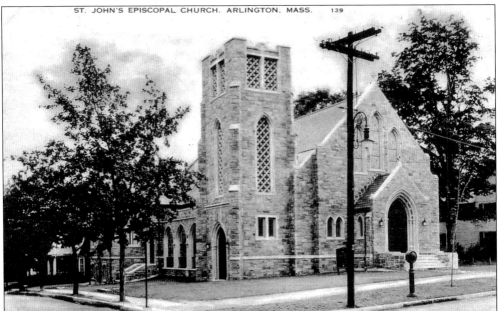

ST. JOHN'S EPISCOPAL CHURCH. ARLINGTON. MASS. 139

The Peck mansion was razed in 1930, but the site remained picture perfect when St. John's Episcopal Church took it over. The church's architect was Alrand A. Dirlam of Malden. After having spent almost 60 years in a wooden church that was intended to be temporary quarters, the Anglican congregation rejoiced at their fine new house of worship. The Friends of the Drama were pleased to make the old St. John's into their permanent quarters in 1933.

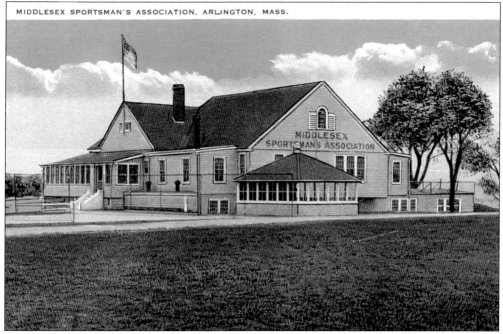

The Middlesex Sportsman's Association purchased the Arlington Boat Club property in 1920 and occupied it for over two decades, after which it was deeded to the Arlington Boys Club. The clubhouse was replaced by a modern structure in the 1960s.

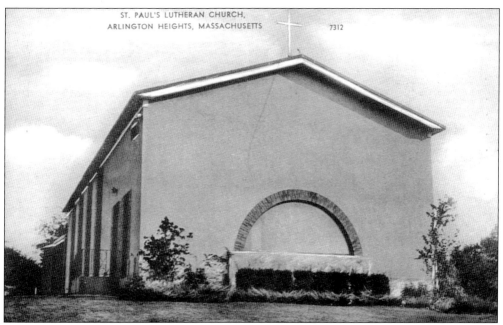

St. Paul's Lutheran Church was constructed on the Concord Turnpike in Arlington Heights in 1952. It was the first church of this denomination in town, despite the fact that many Swedish immigrants lived in Arlington. With the later addition of a cross-topped tower, it has become a landmark to eastbound travelers on Route 2.

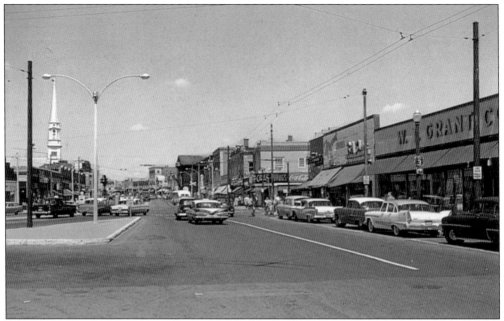

The "gull-winged" rear end of this 1959 Chevrolet and the presence of Arlington's old Town Hall suggest that this postcard shows a c. 1960 view. It provides an interesting street-level perspective of Arlington Center before the 1977 construction of the Broadway pedestrian plaza.

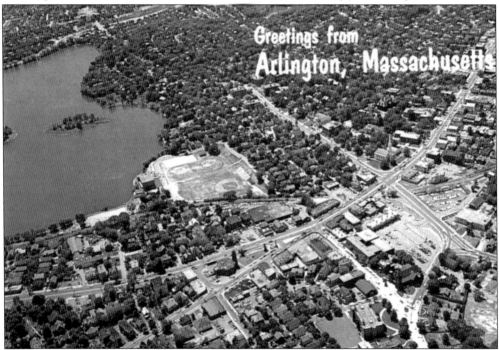

This aerial view of Arlington was taken in the summer of 1964. The large parking lot to the rear of St. Agnes Church and Arlington Catholic High School (in the lower right quadrant of this image) had been paved over only six years earlier. From 1867 until 1958, it had been Arlington's oldest public park, Russell Common.

Five

1950–1974:
Grappling with Growth

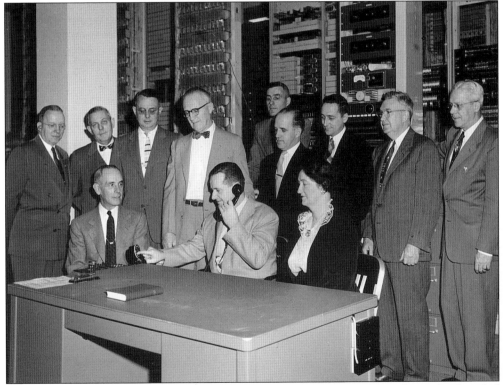

Chairman of the Arlington Board of Selectmen Franklin W. Hurd Sr. places the first dial telephone call in Arlington from the new exchange building at the corner of Pleasant and Maple Streets. The date was May 2, 1955. It had taken an entire decade to catch up on modernization projects delayed by the military production demands of WWII. (Briand Studios.)

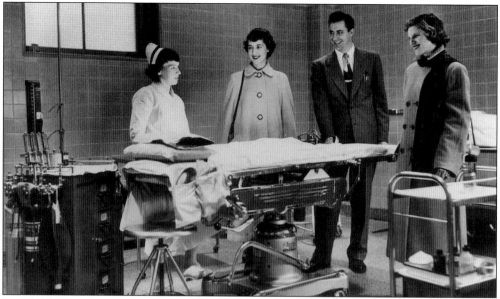

In 1951, a nurse proudly shows visitors the latest in operating room equipment at the inauguration of a new surgical suite at Symmes Hospital. The hospital, which accepted its first patient in 1912, was experiencing ever-increasing demands for its services. There were over 900 babies delivered there in 1950. Massive changes in the economics of health care delivery led Symmes to close its doors in 1999. (*Boston Herald*.)

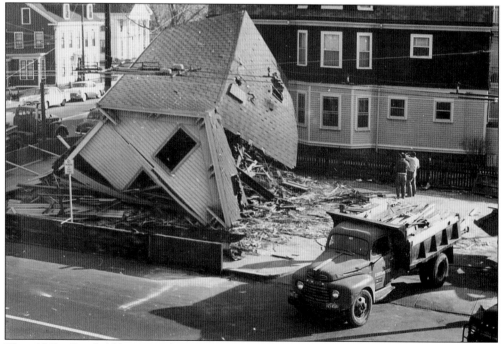

The old Dr. Peatfield house at the corner of Broadway and Franklin Street was demolished to make way for the modern brick showrooms of Gordon Furniture. It had special historic interest as the home of Georgiana M. Peatfield, the first woman to hold elective office in Arlington; she topped the field in the race for the Arlington School Committee in 1896.

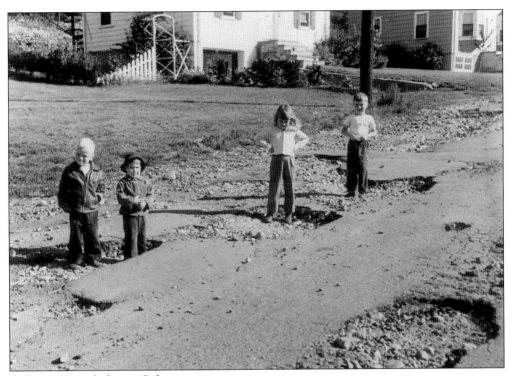

Kids pose in potholes on Oak Hill Road to dramatize the neglect of Arlington streets by a municipal infrastructure that was clearly struggling to keep pace with a boom in postwar residential development. A significant consolation prize for this neighborhood was the imminent opening of the Bishop Elementary School in 1950. (*Boston Herald.*)

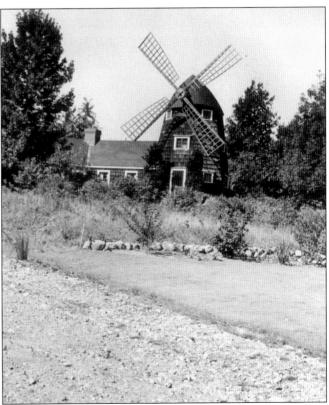

The "Windmill House" at 15 Oldham Road has been a distinctive feature of the "Morningside" section of town since the 1930s. Given the primitive condition of the street, one would have difficulty believing that this was a 1950s photograph in a suburb only six miles west of Boston. (*Boston Herald.*)

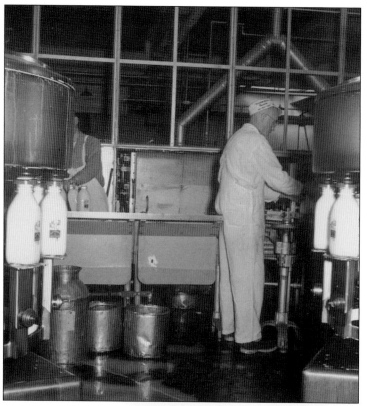

Buttrick's milk-bottling plant was located on Mill Street. Today, it produces 2 million gallons of ice cream a year for Brigham's, which acquired Buttrick's small chain of ice-cream and sandwich shops in 1968 and moved its corporate headquarters to Arlington.

The Buttrick's Dairy milk truck was a familiar sight around Arlington in the 1950s. In 1999-dollar terms, milk cost approximately $4 a gallon, making it a big expense for single-earner families with several children. The competition from the opening of a Cumberland Farms store in 1958 drove milk prices down and spelled the beginning of the end for "the milkman" in Arlington.

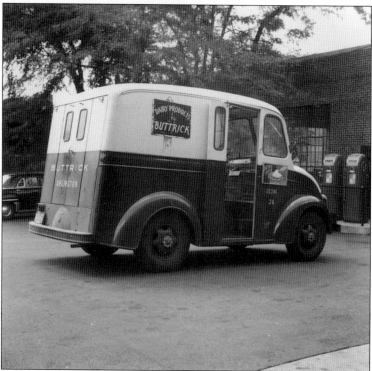

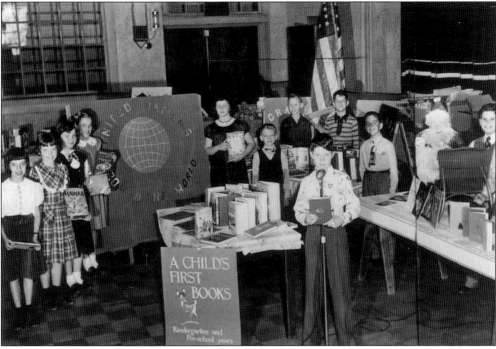

Students pose with pride at this 1950s Christmas book fair held in the old Brackett School auditorium. (*Boston Herald.*)

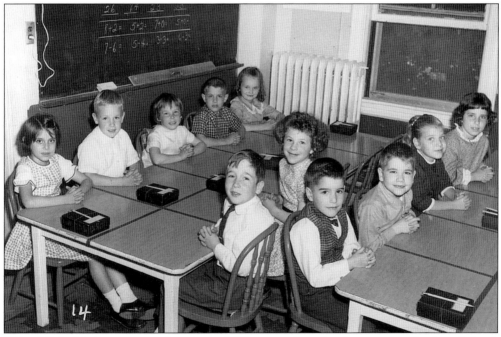

This delightful image was taken in a 1950s second-grade class at the Bartlett School. Mrs. Norine Casey founded the private elementary school in 1933 in the parlor of her 34–36 Bartlett Avenue home. The school prospered under her daughter Miss Norine, who took it to larger quarters in Winchester in the 1970s.

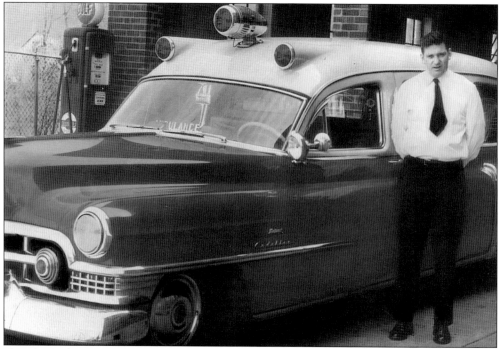

Shortly after returning from the service to his hometown, Bill Armstrong established Armstrong Ambulance in 1947. Here, he is shown with a newly acquired 1951 Cadillac ambulance. The business continued to grow stronger than ever. Since the closing of Symmes Hospital, dedicated Armstrong paramedic units supplement the town's own municipal emergency services.

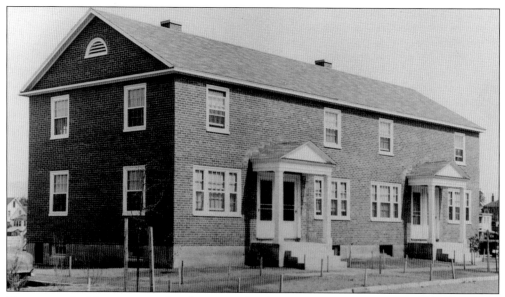

Twenty-one buildings were ready to house 126 families in a subsidized Veteran's housing program by the summer of 1950. Plans for this East Arlington development, today known as Menotomy Manor, began with the creation of the Arlington Housing Authority in 1948. (*Boston Herald.*)

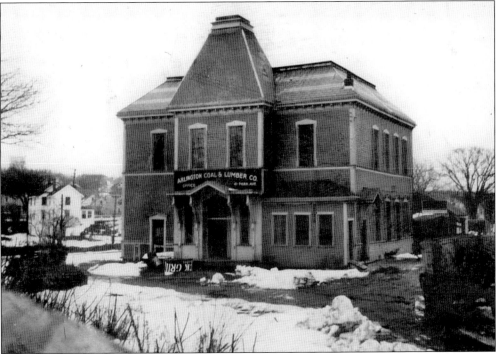

This 1950s snapshot captured the 1878 wooden building of the first Locke School. It was moved down Park Avenue after 1899 to become part of the Arlington Coal & Lumber Co. Today, this business occupies the 1876 Carpenter-Gothic style "Union Hall."

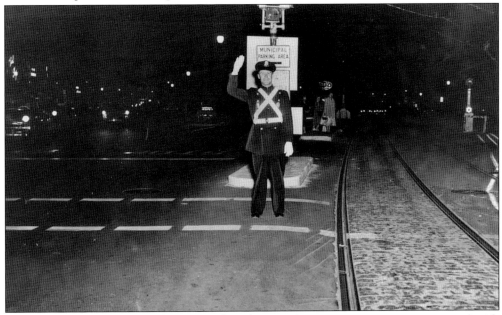

Policemen were once routinely stationed at the town's major intersections to contend with the heavy volume of automobile, bus, streetcar, and pedestrian traffic. Here, an officer models a new "Tri-Lite" safety belt at the junction of Massachusetts Avenue and Medford Street. (*Boston Herald.*)

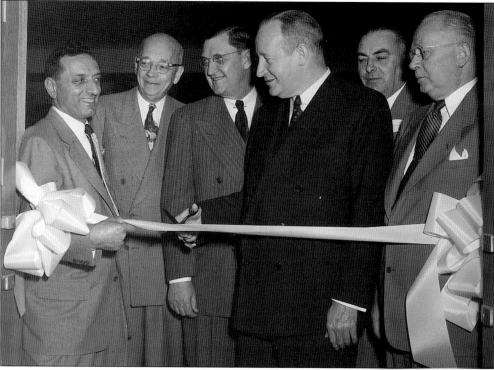

John Mirak holds the ceremonial ribbon to be cut by a regional General Motors executive, opening his new Chevrolet showroom in 1952. Mirak began in the automobile business in 1931 and obtained his Chevrolet franchise in 1936. During the war, the service end of the business was dedicated to keeping existing cars on the road until production resumed in 1946. Mirak seems eager to accept the challenges of modern car marketing.

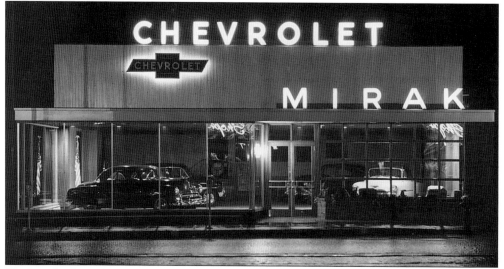

The Mirak Chevrolet dealership at 430 Massachusetts Avenue was a thriving business, although it appears small by today's standards. Arlington once had dealerships for nearly all makes of the American automobile, but Mirak's is among the very few to have been able to increase the scale of its operations yet remain in town.

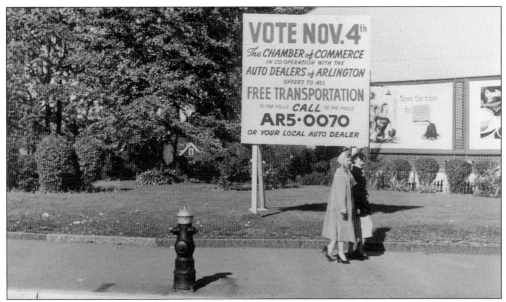

To encourage everyone to cast their ballots in the 1952 presidential-year elections, free transportation to the polling places was advertised. This service continues under various sponsors, primarily for the elderly and disabled, but in the days of the one-car family, many housewives appreciated the convenience. (*Boston Herald.*)

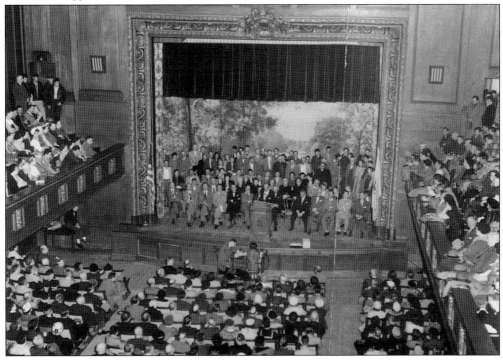

It was reported that some 1,700 citizens "sandwiched" themselves into the Arlington Town Hall auditorium to protest plans to extend Route 3 through town as a multilane highway at the location of Lowell Street. As no officials from either the state or federal government ever showed up, it must have been an excited but friendly gathering. (*Boston Herald.*)

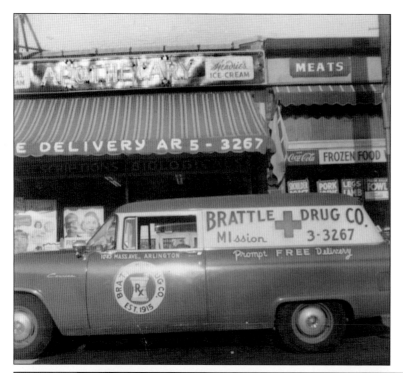

Although this is a photograph of the 1947 delivery wagon of Brattle Drug, we can tell that the photograph was taken c. 1955, because Arlington's new telephone exchange (MIssion 3-) has been painted on the side. Note that the awning just above still bears the old ARlington 5- exchange. Brattle Drug was operated by the Cavaretta family from 1936 until 1999.

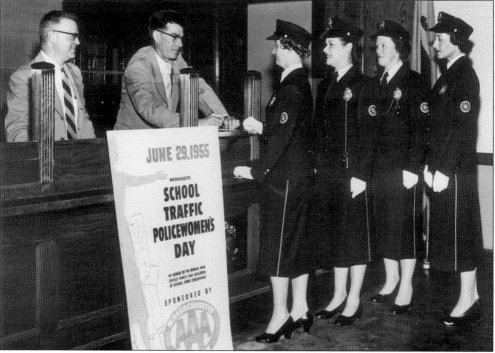

Memories of "the school-crossing lady" are among the fondest of Arlington schoolchildren. Today, most children are driven to school by their parents—to the point that a group of those few who still walk to the Dallin School was "news" in a 1999 *Boston Globe* article. (*Boston Herald.*)

In 1955, Hurricane Diane caused extensive damage in Arlington. In the distance, Russell Street (looking toward Mystic) is completely blacked out by toppled shade trees. In the foreground at left, a section of the handsome fence surrounding the Judge Parmenter House has fallen. The Cadillac at right was either a lucky survivor, or a later arrival on the scene.

An expert detective attempts to lift fingerprints to try to solve a robbery at the old Arlington National Bank in 1956. (*Boston Herald.*)

Back in the days when the evening commute on Pleasant Street could still be described as "pleasant," this request might have been overheard on the lawn of the Laufman home: "Would someone please tell me when Daddy's in sight so I can start the steaks?" Pretty much on schedule, the reply would come back from one of the children: "Here he comes, Mummy, here he comes. He's by Viano's now."

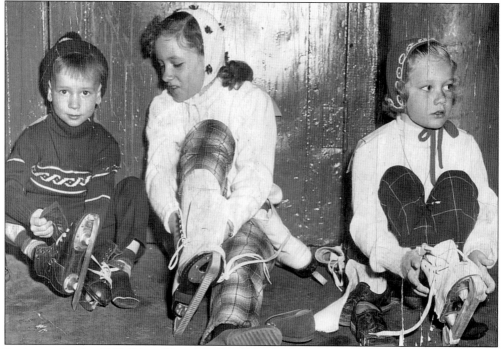

Lacing up for the 1958 Silver Skates Derby at the Boston Garden were 5-year-old Jack Hurd, with sisters Judy Williams and Rosemary Hurd. As this book is being written, Jack Hurd is serving as the chairman of the Arlington Board of Selectmen. (*Boston Record-American.*)

All eyes were on Arlington history in 1957, the 150th anniversary of the town's incorporation. Here, Nelson Capes points out one of the bullet holes in his home—the Jason Russell House. His parents, Irene and George Capes, became caretakers of this Arlington Historical Society property in 1944. To this day, many children believe that Mrs. Capes is in fact Mrs. Jason Russell. (*Boston Herald.*)

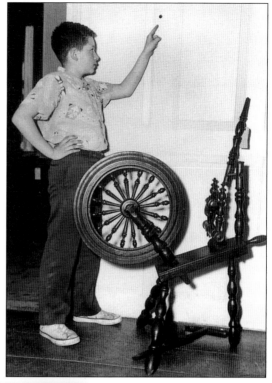

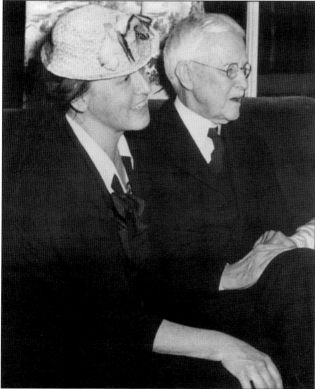

Elizabeth Abbot Smith and her father, George A. Smith, were major benefactors of the preservation and interpretation of Arlington history. They arranged for the demolition of the modern houses that had been built on the Jason Russell House battleground, and funded the construction of the Smith Museum and Archives, dedicated in 1980.

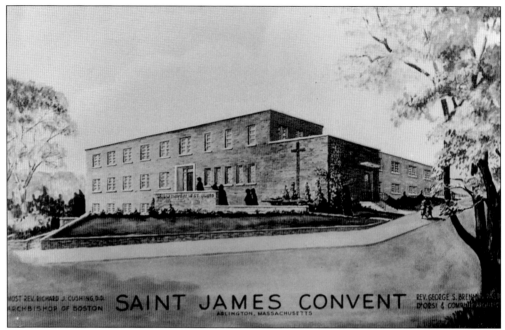

St. James was established in 1914 as the second Roman Catholic parish in Arlington. The teaching sisters of the Religious of Christian Education ran a parochial grammar school there from 1949 until the 1970s. This 1955 sketch shows their handsome Marian convent on Appleton Street. (*Boston Herald.*)

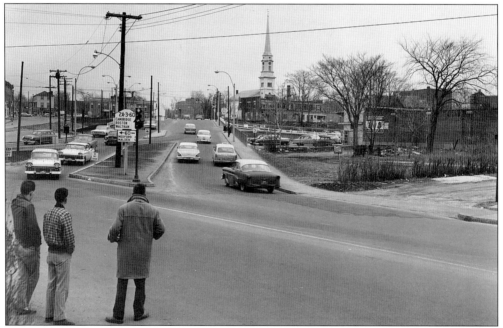

In 1962, Mystic Street was realigned to lead across Massachusetts Avenue and flow directly onto Pleasant Street. Previously, traffic heading to Belmont or Route 2 would have to bear left, take a hard right onto the avenue, then a hard left onto Pleasant Street. It caused bottlenecks of legendary proportions.

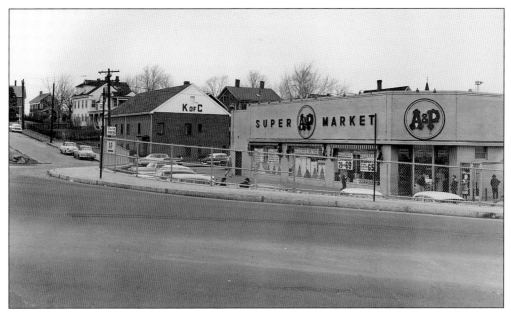

The Arlington Center A&P supermarket was located at the corner of Winslow and Prescott Streets. It went out of business shortly after the realignment of Mystic Street sliced off a big section of its parking lot. The day this photograph was made, 25-pound bags of potatoes were on sale for 69¢. For this to have been a featured item of the week says much about typical family sizes and their eating habits.

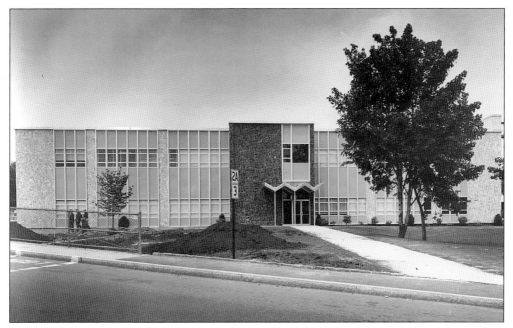

The Mirak Corporation added a new top floor to the old A&P and converted it into a modern office building in 1962. The entrance was moved to face Mystic Street, sheltered by a distinctive zigzag canopy that was lost in a subsequent exterior updating. New England Telephone, long the largest private employer in Arlington, had a local business office here for three decades.

The 1883 Arlington Center railroad station had become the epitome of shabbiness by the early 1960s, and it fell under the wrecker's ball in the early 1980s. Given the tremendous success of the adjacent Minuteman Bikeway (opened in 1992 on the former railroad right-of-way), many say that its preservation would have been a jewel in the amazing revival of Arlington Center.

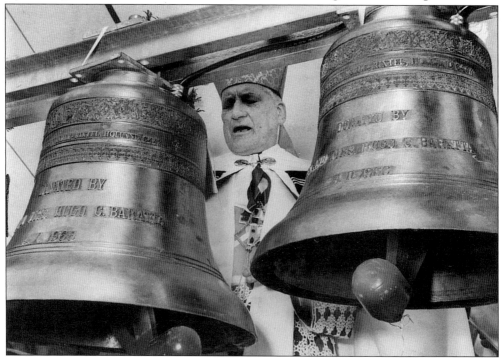

Richard Cardinal Cushing blesses the new bells at St. Camillus church in 1966. The parish was established in 1950 along the Concord Turnpike. It held Mass in what is the current parish hall until the present church was dedicated in 1961. At that time, the Archdiocese announced plans to construct a high school for girls on an adjacent 13-acre parcel; however, these plans were never carried out.

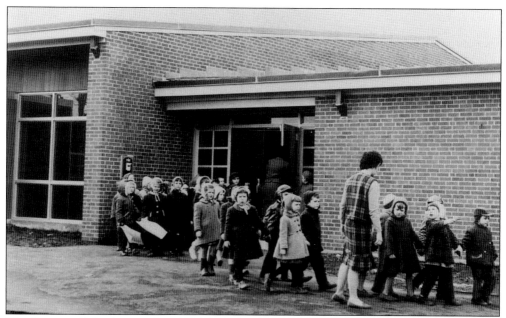

The Stratton School opened in 1962 to serve students in the upper Morningside area. Since WWII, old school buildings had been enlarged and three other new elementary schools constructed: the Bishop, Thompson, and Dallin Schools, allowing the aging Russell School to close its doors. (*Boston Herald.*)

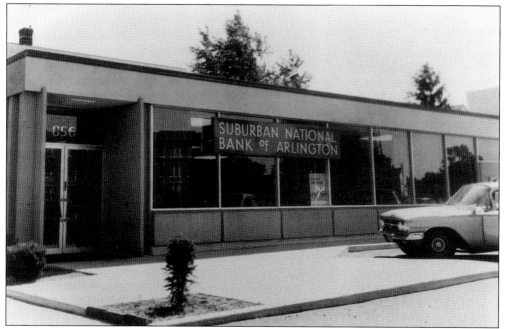

The Suburban National Bank of Arlington was the last locally established bank in town when it opened in 1962; it was the only remaining Arlington-based bank when it was sold to Lexington Savings a quarter century later. It had outlasted the Arlington National and the Arlington Co-Operative Banks (both sold many years earlier), as well as the town's oldest financial institution, Bank Five, which failed in 1991. (*Boston Herald.*)

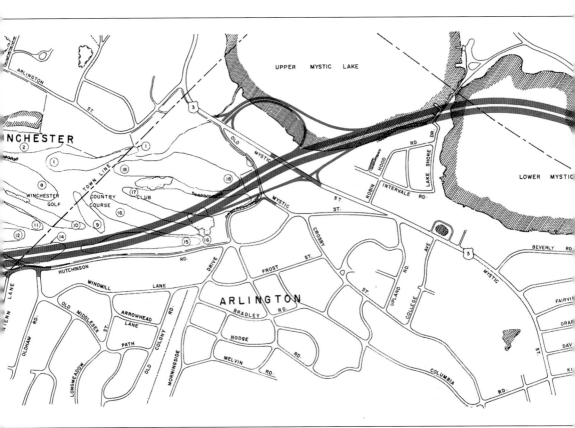

After plans were abandoned in 1954 to run Route 3 as an expressway down Lowell Street, state highway authorities published revised plans in 1962. A six-lane highway cutting through Ridge Street was the first choice but would have involved the taking of expensive private real estate. The alternative proposal, shown here, was grotesque. The dark bands shown across the Mystic

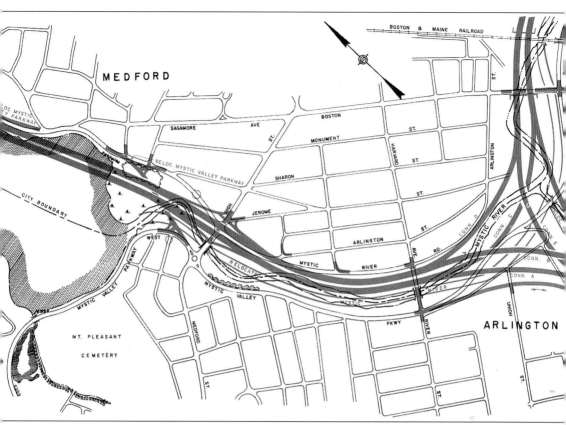

Lakes and over the Winchester Country Club golf course represent elevated highway spans. Not until Gov. Francis Sargent's 1969 new highway moratorium did the specter of cutting such an awful gash through town vanish forever.

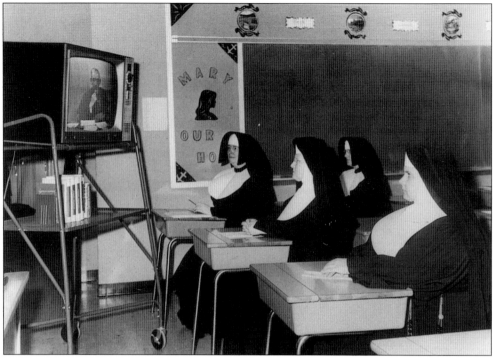

Arlington Catholic High School opened in 1960, staffed by the Sisters of St. Joseph. Although it incorporated two floors of the 1872 Russell School building in its design, it was quite modern in all other respects. Here, some of the teaching nuns are watching a television to be used as an aide in classroom instruction. (*Boston Herald.*)

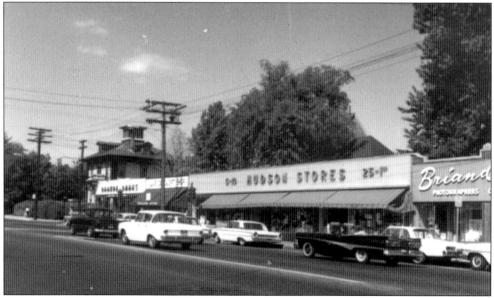

This view along Massachusetts Avenue in East Arlington features the Briand photographic studio and the Hudson Store that replaced Reiks 5- and 10-¢ store in 1956. Ralph Hudson opened his first "five and dime" in Arlington Heights in 1947. Today, Balich's in the Heights is the sole survivor in town of this venerable retail tradition.

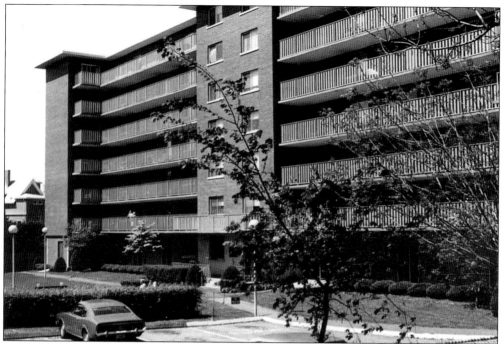

In 1965, the Arlington Housing Authority built Chestnut Manor for the elderly, whose increasing needs for public housing could not be met by the Drake Village development in the Heights, which had opened in 1957. Chestnut Manor is sited well back from Chestnut Street, slightly below street grade, so it blends nicely into the surrounding landscape.

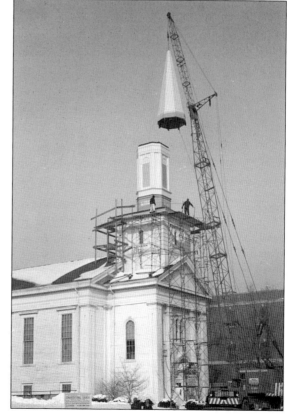

The Pleasant Street Congregational Church lost its steeple in the Hurricane of 1938. Exactly a quarter century later, it was decided to replace it. A prefabricated model was selected, although it was not in very good proportion to the 1844 meetinghouse it would crown. Here, it is shown being lowered into place during the winter of 1964.

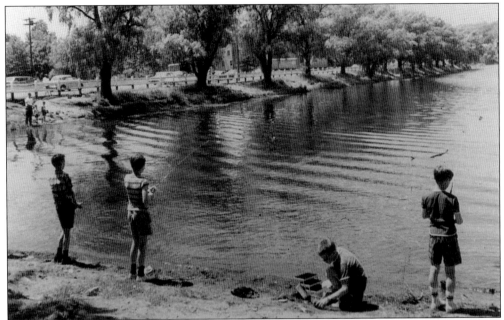

Fishing is enjoyed during the final weeks of the old Spy Pond shoreline in June 1967. Behind the row of willow trees runs the Concord Turnpike, built in the 1930s to relieve congestion on Massachusetts Avenue. The opening of Route 128 and growth in the western suburbs during the 1950s meant that this section of Route 2 was dangerously beyond its intended capacity. (*Boston Herald.*)

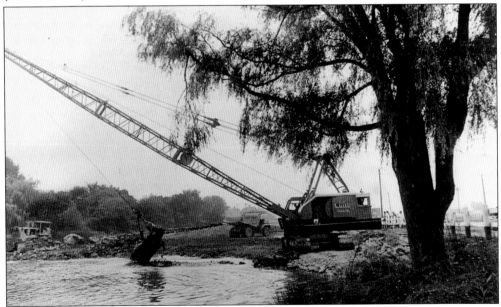

Plans were consequently approved to build a superhighway between Alewife Brook Parkway and Route 128, which cut a massive artificial canyon between Belmont and Arlington. Furthermore, to avoid expensive land taking on the south, it was decided to widen the highway by using 4.6 acres of Spy Pond. The beginning of filling operations is shown in this August 1967 image. (*Boston Herald.*)

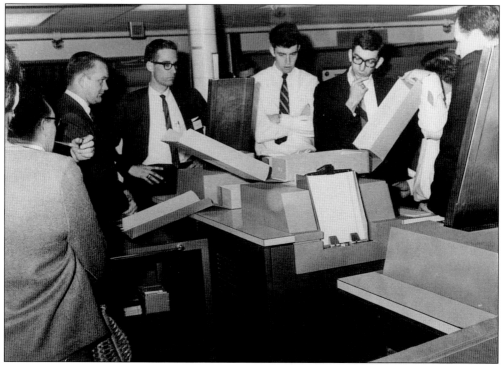

Arlington adopted a punch-card system of computerized voting in 1968 to speed up the long counting process that paper ballots entailed. The computer proved to be problematic. Here, experts from IBM and town voting officials ponder a momentary hitch in the new process. (*Boston Herald.*)

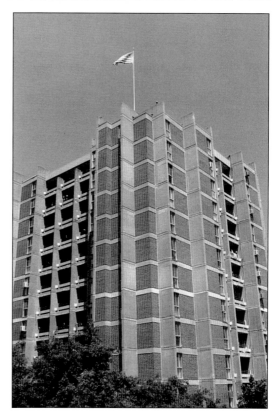

Winslow Towers was conceived as much needed public housing for the elderly in 1968. At that time, a 14-story structure providing 136 apartments seemed like a good solution for a town with little available public land. Despite its success in providing a satisfying community life for its residents, it was determined that the architecture of similar developments must intrude less upon the suburban character of Arlington.

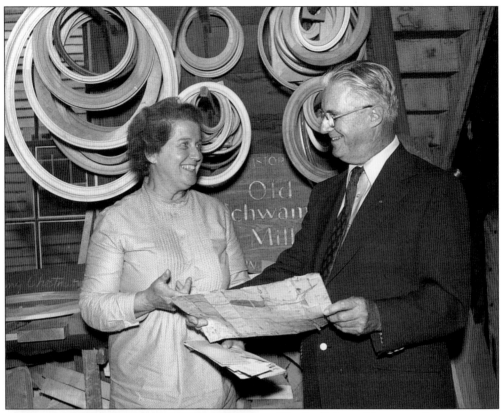

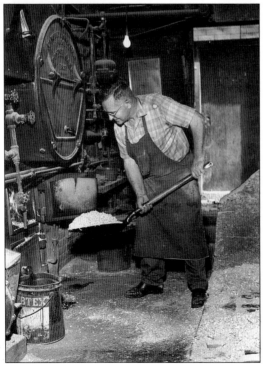

Charles Schwamb's picture frame manufactory faced almost certain destruction in 1969 until it was rescued through amazing efforts of local citizens, led by Patricia C. Fitzmaurice. They established a trust that has ever since preserved it as the Old Schwamb Mill. On an auspicious occasion in 1971—the day the mill received its individual listing on the National Register of Historic Places—Mrs. Fitzmaurice reviews a diagram of the old pond and millrace with Elmer Schwamb, the last family member to manage the mill.

In 1971, coal and sawdust (the latter fuel a by-product of the frame manufacturing process) were still used to heat the mill. Ronald MacLellan tends the boiler room fires in a separate building on the site. Today, the Old Schwamb Mill operates as a living museum. It is a most remarkable survivor of the many small water-powered industries that operated on the Mill Brook and the Mystic River for centuries.

For its first 15 years, the Old Schwamb Mill operated as an artisans colony, renting studio space and offering a varied educational program to the public for woodworking, ceramics, and other crafts. In the silhouette of a viola da gamba, Richard Hart works on his reproduction of the rebec, an ancient stringed instrument.

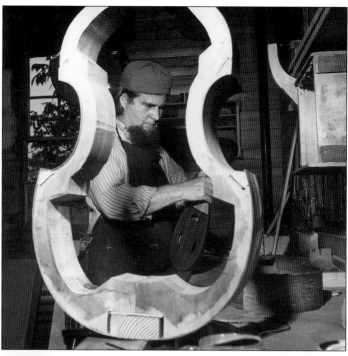

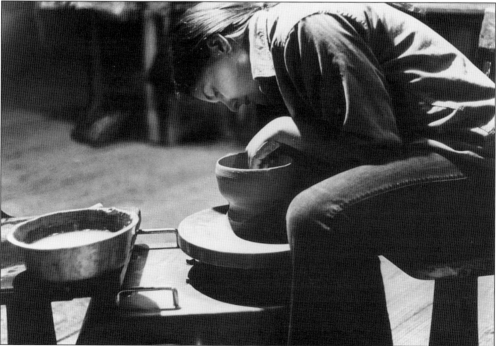

The construction of gas-fired kilns at the mill attracted expert potters for whom high-temperature glazing techniques had been previously unavailable in the Boston area. While this potter works at her wheel in a basement studio, the 19th-century woodworking machinery continued to turn overhead and produce the museum-quality oval and circular picture frames for which the Schwamb mill remains famous.

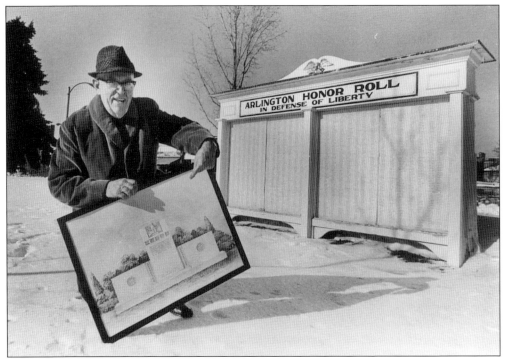

Joe Barry poses in 1972 with a sketch of the proposed veterans' memorial to serve as a more substantial reminder than the Arlington Honor Roll. Since WWII, Arlington had lost another 11 men in the Korean Conflict. Two thousand men and women from Arlington served in the Vietnam War, nine of whom were killed in action. (*Boston Herald.*)

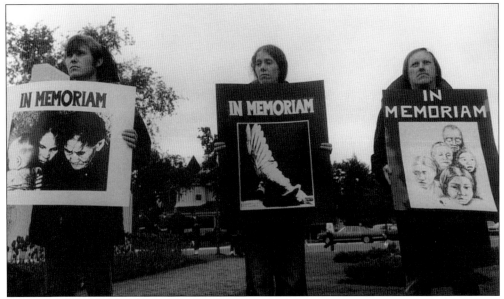

The Vietnam War divided Americans as no other military conflict before or since, and feelings ran as deep in Arlington as on any college campus in the early 1970s. While traditional Memorial Day exercises are being conducted at Monument Park, these poster bearers stand in memory of the many deaths among the civilian population of Southeast Asia. (Norman Hurst.)

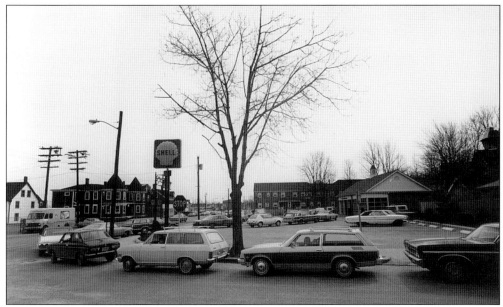

The Arab oil embargo of 1974 produced many scenes such as this one, in which a long line of cars is snaking down Coleman Road awaiting gasoline at the Massachusetts Avenue Shell station. Many energy-saving measures were introduced in that year, such as the elimination of outdoor Christmas lighting and the first serious fuel conservation campaign since WWII. (Norman Hurst.)

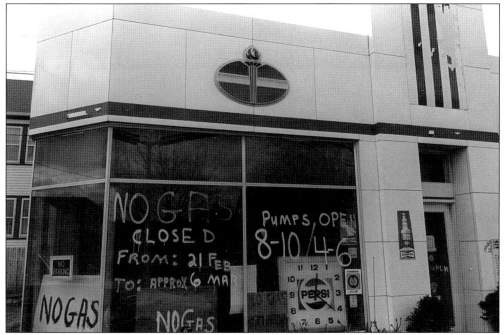

From the varied array of signs in the window of this American (later Amoco) station, we can see that the owner at first tried to operate with a daily limit of four hours on gasoline pumping. Then he was forced to announce a gas-less Saturday, followed by no gas at all for two weeks. In addition to "no gas," there was also "no parking." (Norman Hurst.)

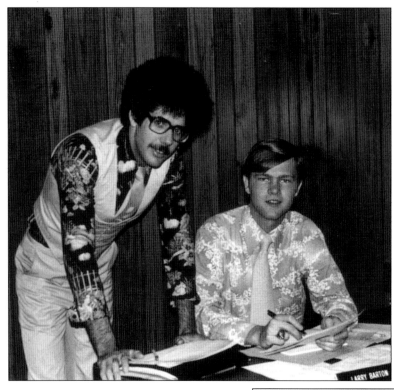

All was not bleak in the mid-1970s, at least not the wardrobes of Larry Barton and Bruce Georgian of the Arlington Housing Authority. These gentlemen were right in step with America's expanded use of synthetic fabrics, a departure from the starched white shirt as a man's sole option for business attire. "Casual day" (meaning no neckties required for men) was not invented until the 1990s.

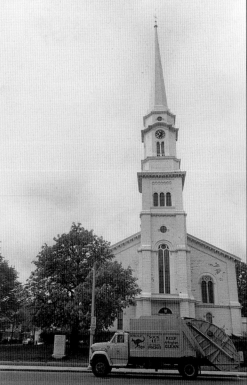

A municipal garbage truck, emblazoned with mascot Kingsley the Kangoroo, rolls past the fourth meetinghouse of the First Parish Congregational (Unitarian-Universalist) Church in the summer of 1974. The peeling paint on the façade of the 1856 Italianate-style church suggests that it had some major sprucing up to accomplish in order to shine at the Bicentennial celebrations in 1975. (Norman Hurst.)

Six

1975–1999:
The Bicentennial
and Beyond

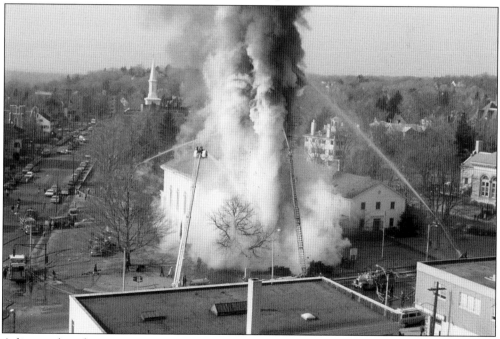

Arlington lost the most conspicuous ornament of its historic town center when the Unitarian-Universalist church was destroyed in this spectacular conflagration on March 7, 1975. The careless use of a blowtorch during work on the steeple is said to have started the fire. John Crowley captured the height of this tragedy from the roof of the Winslow Towers.

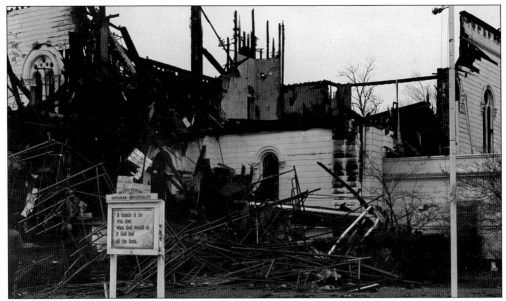

When the smoke had settled by next morning, it was clear that very little of the front façade remained. This shocking loss was felt deeply by the members of the First Parish, who expected to see their church building looking nicer than ever in the next month's Bicentennial celebrations. Only the salvaged tower bell, set out on a special platform, stood as reminder of the physical church when the great parade passed by on April 19, 1975.

Many had hoped that reconstruction of the old church would be possible, as substantial sections of the side and rear elevations had survived. Proponents of this idea noted with dismay that the bulldozer "had to stand on its hind legs" to take down sturdy walls that others had concluded were beyond hope. The decision to build a replacement church of dramatically modern design remains controversial 25 years later.

Despite the loss of the First Parish's meetinghouse, the Bicentennial celebration was primarily one of people. In this spirit, the Unitarian-Universalist minister, the Reverend Charles Grady, carried on in one of the leadership roles in Arlington's festivities. At one of the two "Colonial Balls," from left to right, we see the Reverend Grady and his wife, Claudine; Mrs. Edward Murphy and Mr. Murphy; Mrs. Corcoran and Town Moderator Larry Corcoran; Dorothy Sexton and her husband Ralph W. Sexton, president of the Arlington Historical Society.

Other participants in the jollification were, from left to right, Patricia C. Fitzmaurice, who served with George "Brud" Faulkner as cochairman of the Bicentennial Planning Committee; Dr. Kenneth Spengler; John A. FitzMaurice, who is lately of the Redevelopment Board; and Margaret "Peg" Spengler. Mrs. Spengler was the first woman in Arlington to win election as a selectman in 1973. Town Clerk Ann Mahon Powers was the first woman to serve in that office by appointment.

Leading his wife, Elaine Marquis, on the dance floor is Town Manager Donald Marquis. Marquis is only the second town manager to be appointed in Arlington since that model of municipal administration was adopted in 1952. He replaced Edward Monahan in 1966 and is to retire from a long and truly distinguished career at the end of the year 2000.

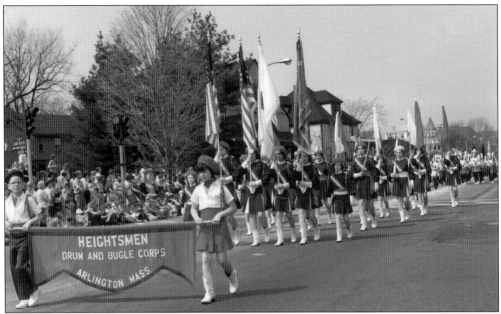

The great Patriot's Day parade of April 19, 1975 was said to have been the nation's largest of the Bicentennial. Here, the Heightsmen Drum and Bugle Corps is approaching the intersection of Jason Street and Massachusetts Avenue. Note the sign of the old First National supermarket (now Johnnie's Foodmaster) in the background.

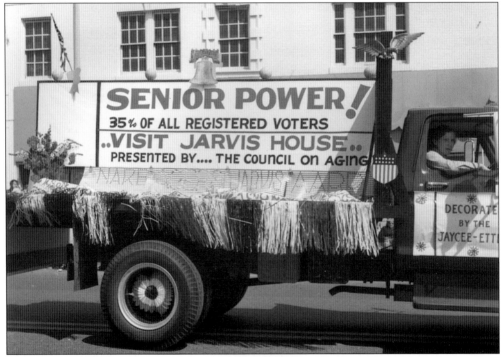

The "Senior Power" message on this truck recognized the emerging political force of a growing population of elderly citizens, encouraging them to activism on behalf of their many common social and economic concerns.

Passing by the Belden and Snow gentlemen's shop, these Girl Scouts are accompanied on their march by a decorated Volkswagen "Bus." This type of vehicle, an early hybrid of a car and a van, was a bit of an oddity in 1975. Little could spectators have imagined that the profusion of minivans would start to replace the traditional family station wagon in the 1980s.

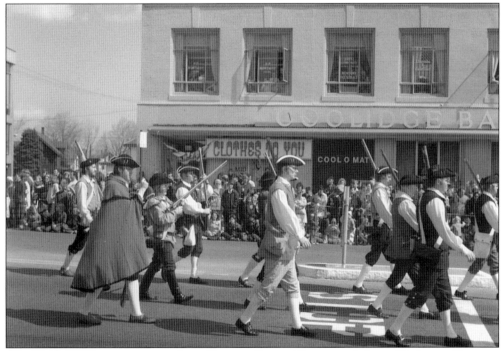

A unit of minutemen is approaching Pleasant Street. The apparel shop, Clothes to You, is a playful take on "Close to You," a hit song of the 1970s by the Carpenters. The Cool-O-Mat in the background was Arlington's first automated teller machine (ATM), a concept pioneered in the industry by Coolidge Bank.

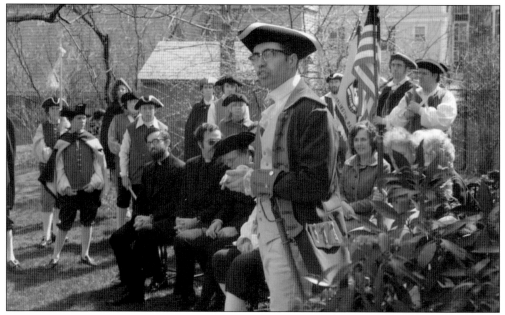

John L. Worden III has long since traded his tricorner hat for the town moderator's gavel. The longtime historic preservation activist is speaking to a group gathered on the lawn of the Jason Russell House to honor the important events that took place there on the first day of the American Revolution.

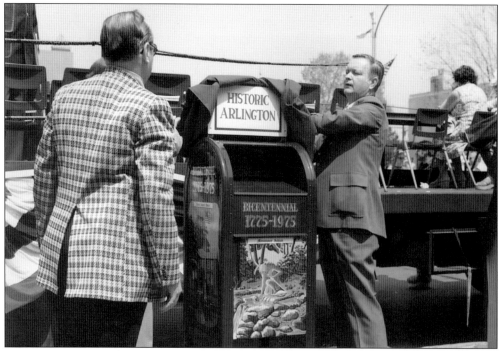

Some places and events merit commemorative postage stamps. For Arlington's Bicentennial, it was a commemorative U.S. mailbox. John Bilafer is in charge of the unveiling in front of the Arlington Town Hall, where he has served as a selectman and where voters enthusiastically continue to return him to his long-held office of town treasurer.

Passing the time while waiting to be called for a fare are the drivers of Dewey's Cab. They are lined up on Railroad Avenue, which was recently renamed David Lamson Way after the African-American Revolutionary War hero. (Norman Hurst.)

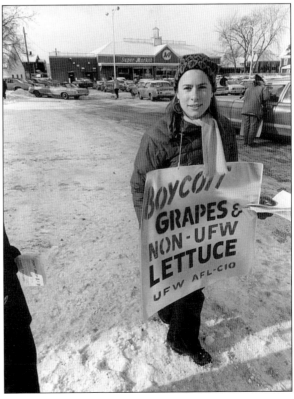

In another scene from the mid-1970s, solidarity with California's migrant farm workers is expressed in the parking lot of the A&P supermarket, which today is the site of the Massachusetts Avenue Walgreen's, located between Arlington Center and East Arlington. (Norman Hurst.)

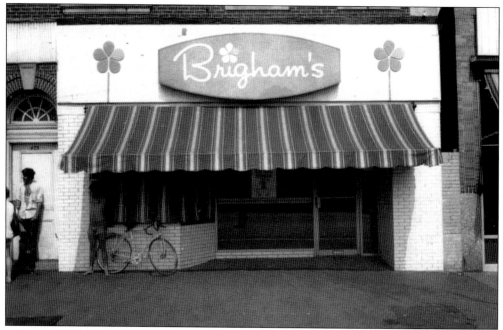

The Brigham's Ice-Cream and Sandwich Shop in Arlington Center was a popular spot from 1956 until it closed in 1988. Many a box of Mother's Day chocolates were purchased here over the years, and Brigham's "Belmont Twigs" were a perennial favorite.

Although this one-story commercial block on Broadway was of course a bit homely, the W.T. Grant store is certainly missed by longtime residents. The nationwide Grant's chain went out of business in 1976. When finally it came time for Helen's Pastry Shoppe to close its doors, the sadness across town was palpable. (Norman Hurst.)

Thanks to untiring efforts of Arlington's Planning Department over the last 20-plus years, gone are the jumble of signs and inappropriate exterior renovations that had rendered many of Arlington's fine old commercial blocks unsightly. Today, a thriving dining and shopping scene characterizes the Massachusetts Avenue business corridor—a true success story from end to end.

The universally loathed gas holder tank looms above Grove Street. It remained an element of the Arlington landscape from 1923 until 1977. The Cumberland Farms store occupies the historic Peppard's blacksmith shop. Its destruction and replacement by an enlarged convenience store was opposed by preservationists to no avail. (Norman Hurst.)

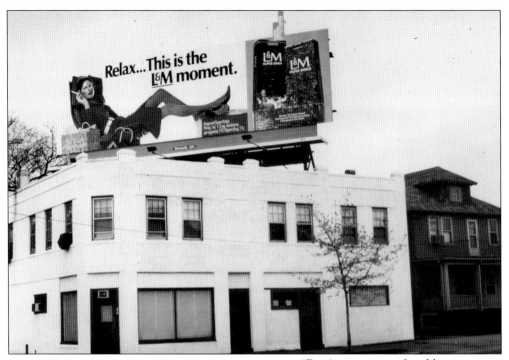

"Don't get too comfortable up there, Ma'am!" Undignified billboards, such as this one that greeted people entering Arlington from the east, vanished forever in 1977. (Norman Hurst.)

Vandalism decreased greatly in the last quarter of the 20th century, with heightened neighborhood vigilance and greater enforcement of underage drinking laws (a brief experiment in the 1970s to lower the drinking age from 21 to 18 had been reversed by 1980). Fortunately, scenes such as these toppled headstones in St. Paul's Catholic Cemetery are less frequently observed in Arlington. (*Boston Herald.*)

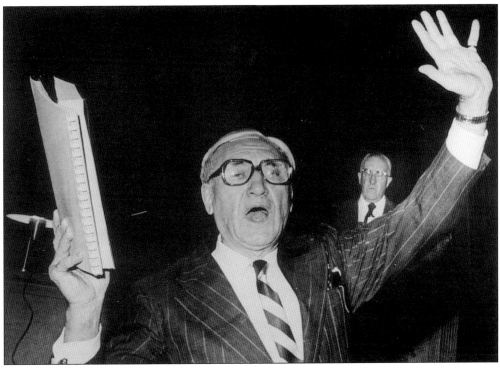

Arlington's legislative tradition of the town meeting dates back to Colonial times. The population growth of the early 20th century, along with the enfranchisement of women, meant that the previous all-voters forum had gained too many participants to be effective. A representative form of town meeting calling for 252 elected members was instituted in 1922. The tradition of vigorous floor debate never changed, however. Here, Modestino Torra speaks on a property tax issue in 1976. (*Boston Herald.*)

Voting booths in the corridor outside the Arlington Town Hall auditorium await voters in a March 1978 referendum concerning major renovations to the high school. After having failed twice in the previous year, a modified proposal was approved this time around. (*Boston Herald.*)

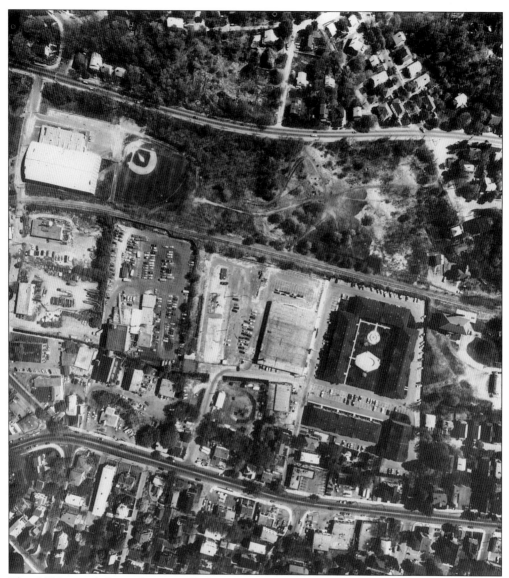

This 1980s aerial shot is horizontally bisected by Summer Street to the north, Massachusetts Avenue to the south, and the railroad tracks in the middle. In the upper left quadrant is the Veterans Memorial Ice-Skating Rink, built in 1958. To the right of the baseball diamond is the Buck's Field conservation area. Below Buck's Field, the swimming pool in the center of the Old Colony Condominiums makes that residential complex easy to identify. The Massachusetts Avenue frontage in the lower left quadrant of this image has seen considerable improvement by construction of the modern Mirak Chevrolet and Hyundai dealerships. Behind the latter, the historic structures of the Theodore Schwamb Piano Case Factory on Mill Brook remain in active business use for multiple tenants of the Mirak Industrial Park.

In 1980, Massachusetts voted to enact "Proposition 2½" to cap local property tax increases from year to year. The resulting budget cuts were frequently painful. Here, librarian Page Lindsay prepares for the closure of the Fox Branch Library in 1989. Arlington voters later approved an override to the real estate tax cap, enabling the East Arlington library and community center to reopen. (*Boston Herald.*)

Teacher Gilbert Mello sadly contemplates the announced closure of the 1927 Gibbs Junior High School in East Arlington in 1989. Continued declines in student enrollment played the major role in this decision—five elementary schools having already closed by 1985. Arlington's population peaked at 52,000 in the 1970s. Not only have its total inhabitants decreased to 44,000 at century's end, this population is spread over many more households with a much lower average number of children in each. (*Boston Herald.*)

The automobile has been king on Massachusetts Avenue for most of the 20th century but by the mid-1980s, pedestrian safety was evolving into a major concern. Since the time of this 1984 photograph, drivers seem to pay better attention to "stop at the crosswalk" laws that had been ignored for generations. Pedestrian safety remains a major area for improvement in Arlington's quality of life. (*Boston Herald.*)

Fortunately, members of the Arlington Fire Department have not had to contend with a major toxic chemical disaster but as can be seen in this image, they are kept up-to-date in the latest safe disposal techniques. One hundred years ago, the role of the department was confined to combating blazes. Today, it has expanded to emphasize fire prevention and the delivery of emergency medical services. (*Boston Herald.*)

With dedication comes danger. The Arlington firefighters shown here have just been relieved by colleagues in the battle against a three-alarm fire at 81–83 Medford Street. Conditions were worsened by the summer heat on July 21, 1992. (*Boston Herald.*)

With the tender respect deserved by all living victims, oxygen is administered to the family's pet cat, rescued from the above house fire. (*Boston Herald.*)

In a town with precious little open land for development, fire is no longer the primary hazard to the survival of historic structures. This *c.* 1840 Greek Revival home at 48 Broadway (where the Pichette Dairy once operated) is shown on the first leg of its rescue in November 1997. Rosemary Schultze and her husband, Bob Fredieu, completed its move in June 1998 to 235 Pleasant Street, where the house was extensively restored to make a handsome new contribution to the Historic District.

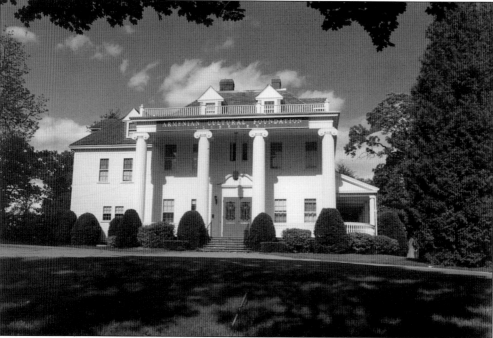

Rescuing and preserving important books, documents, and objects is the important mission of the Armenian Cultural Foundation and Library, which has been located at 441 Mystic Street since 1964. The continuing presence of this institution at the end of the 20th century helps to assure that the violent persecution and dispersion of the Armenian people in the early 1900s will not have succeeded in extinguishing their rich cultural history.

There are few one-screen cinemas still operating in suburban town centers, but the 1916 Regent Theatre has adapted to the times—from "dollar night" movies to children's theater to operas. Bombay Cinema is its most recent incarnation, showing first-run films to delight the area's growing population of Indian immigrants. In the spring of 1999, live broadcasts of the World Cup cricket matches drew a multinational crowd of fans.

The annual Grecian Festival of St. Athanasius the Great Church draws throngs from Arlington and vicinity to enjoy splendid homemade Greek food, wine, and dancing. On the Saturday of the three-day event, traditional spit-roasted pigs and lambs are prepared right out on Massachusetts Avenue.

The Arlington Historical Society celebrated its centennial in 1997, during which it inaugurated its first permanent exhibit, "Centuries of Change," in the Smith Museum. Designed by Arlington resident Lisa Anne Welter, it takes visitors along an informative and entertaining timeline, running from prehistoric times to the approach of the new millennium. In the year 2000, interest in Arlington history was at an unprecedented high among old and new residents alike.

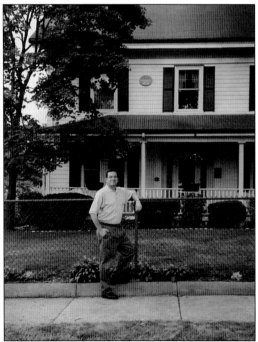

My research into the life of Benjamin F. Woods and his 19th-century tide mill on the Mystic River uncovered a colorful and long-forgotten chapter of Arlington's industrial history dating back to the early Colonial era. Pausing in front of the Woods house at 181 Franklin Street, I wonder what tales of the 20th century similarly have vanished from memory—perhaps awaiting revival 100 years from now?

Epilogue

Shortly after planning had begun for the town's "Arlington 2000" millennium celebrations, I was approached to do a photographic history of local life throughout the 20th century. *Arlington*, my 1997 book in Arcadia Publishing's *Images of America* series, covered the years 1807 to 1950 and apparently left more than a few readers eager for a follow-up volume. At first, I felt gratified by the request for me to bring Arlington's history, quite literally, right up to "yesterday."

My next reaction was one of dismay. I knew that among the known sources of images of Arlington in the early 20th century, "all the good ones had been taken" and used in the last two chapters of my previous book. Showcasing the first 50 years of growth in town by using "leftovers" was out of the question. Moreover, I had envisioned having several years to gradually gather images from WWII onwards, perhaps for a book commemorating Arlington's 200th anniversary as a town in 2007. This would be a leisurely pursuit, enjoyed over many cups of tea and long reminiscences.

I quickly realized what a challenge I had on my hands. It would mean spinning gold from straw—and fast! If I saw an old newspaper advertisement for the grand opening of a vanished business, I tracked down the family of the retired merchant for some photographs. Almost any Arlingtonian with more gray hairs than I was either pursued to provide something interesting from the family scrapbooks—or at least to direct me to someone else who could help. Serendipity was responsible for some of the best material in this book, vintage photographs that "came in over the transom" in the final weeks of production. I was having difficulty choosing from an overabundance of fine images.

To close this volume, I shall indulge in sharing bits of my "wish list" for 20th-century photographs and memorabilia that someday will make more complete our visual record of the last 100 years: Symmes Hospital and Ring Sanitorium nursing students and staff, the 1920s public school building boom, the cupola-raising at Calvary Methodist Church, a wedding at the Church of Our Saviour, the (first) heyday of the Capitol Theatre, Kelwyn Manor under construction, the Lend-A-Hand Clubs, Alson's Shoe Shop, the Baptist and Methodist churches in Arlington Heights, the first Town Day in 1977, the Blizzard of 1978, the opening of the Minuteman Bikeway in 1992, the *two* "once-in-a-hundred-year" floods of 1996 and 1997, the opening of the Cyrus Dallin Museum in 1998, and the "Arlington 2000" millennium celebrations.

Whatever looks interesting to my readers is likely to be twice as interesting to Arlington historians, so please do not wait until 2006 to decide what's "worth" sending in. Yesterday may not be old, but it's already history.

Acknowledgments

In the course of designing and writing *Arlington: Twentieth-Century Reflections*, I received the warm interest and generous cooperation of many individuals. Special recognition for their assistance is owed to Jennifer DeRemer of Robbins Library; Patricia C. Fitzmaurice, managing trustee of the Old Schwamb Mill (not to mention the town's measurer of wood and bark); Nora Frank; Bill Mahoney; and Lisa Anne Welter. I never could have "multitasked" this project without having such "multifriend" support.

I am deeply grateful to individuals who answered the call for photographs: Ralph W. and Dorothy Gleason Sexton; Frank Hurd; Bob Mirak; Mother Christopher, OSA; Diane Leach; Katherine and Donald Bennett; Ann Crosby Onthank; Dudley Laufman; Jack Wheatley; Claire Sexton Gibbons; Mark Wanamaker; Len Kuhn; Norine Casey; Martha Bund; Julie Corwin; Teresa and Dean Harrington; Don Mattheisen; Rosemary Schultze and Bob Fredieu; and Bill Armstrong. A framed-works conservation grant from the Massachusetts Cultural Council, administered by the Arlington Arts Council, made additional images available for reproduction.

Photographic resources at organizations other than the Arlington Historical Society were indispensable to the success of this book. I offer my sincere thanks to John Cronin of the *Boston Herald*, Ruth Thomasian of Project SAVE Armenian Photograph Archive, Lorna Condon of the Society for the Preservation of New England Antiquities, Jay Griffin and Michael F. Bradford of the Medford Historical Society, and Ruth Hummel of the Plainville Historic Society in Connecticut.

For their various ways of providing production assistance, I recognize several members of the Arlington Historical Society: Jim Gibbons, president; Ellie Matthews, secretary; Sally Rogers, director at large; and Jean Dolan, volunteer *extraordinaire*.

My editor at Arcadia, Amy K. Sutton, has been a pleasure to work with, and I particularly value her professional insights on the special characteristics necessary for the creation of a successful second volume on a community's history.

On a personal note, thanks to my dear friend Jeanne Stephenson-D'Amore of An American Bed and Breakfast. My sister, Jane Hughes, and Gary Oravetz prepared Thanksgiving dinner and worked on making my Coral Gables house into more of a home, while I had to spend far too much time squirreled away in my study during the critical last phases of writing.

José M. Rodríguez provided a skilled editing eye, patiently cross-referenced the images to the layout and scanning guides as often as was necessary (and then again) and acquired deep expertise in precisely locating Federal Express branches around the world that stay open late. He is respected, admired, and profoundly thanked for his unfailing support.